C000229327

THETFORD & BRECKLAND

THROUGH TIME

Frank Meeres

AMBERLEY PUBLISHING

First published 2010

Amberley Publishing Plc
Cirencester Road, Chalford,
Stroud, Gloucestershire, GL6 8PE

www.amberley-books.com

Copyright © Frank Meeres, 2010

The right of Frank Meeres to be identified as the
Author of this work has been asserted in accordance
with the Copyrights, Designs and Patents Act 1988.

ISBN 978 1 84868 453 9

British Library Cataloguing in Publication Data.
A catalogue record for this book is available from
the British Library.

Typeset in 9.5pt on 12pt Celeste.
Typesetting by Amberley Publishing.
Printed in the UK.

Introduction

Thetford and the surrounding countryside of Breckland has an extraordinarily rich and varied heritage, and has been home to a great number of fascinating and unusual people. Four thousand years ago, men were digging out the flints below the sandy Breckland surface to use as tools: Britain's first industrial landscape. The earliest works in Thetford are the banks and ditches of the castle site, the remains of an Iron Age fort alongside the ancient track-way called the Icknield Way. This crossed the river at the place now called Nuns' Bridges. The crossing was originally not a bridge but a ford, and gave the town its name: Thetford means 'the people's ford'.

Saxon Thetford was an important town at the heart of East Anglia. There was a monastic house from at least 1020 (on the site of the present British Trust for Ornithology) and many churches. The grammar school boasts proudly of a pre-Conquest foundation. Battles between Saxons and Danes were fought in the area: best-known of the Viking leaders is Swegn Forkbeard, who was here in the winter of 1004 and is commemorated on the old town sign, the first of an enormous number of incomers to make their mark on the town.

The Norman Conquest of 1066 changed the face of Thetford. The Bishop of East Anglia moved here from the village of North Elmham in 1071 – only to move again in 1096, this time to Norwich. The Castle was built in the centre of the Iron Age fort, surmounted by a long-gone building of wood or stone. There were perhaps twenty churches, three of which survive, and several monastic houses. The most spectacular is the Cluniac priory, the burial place of several of the Dukes of Norfolk in the Middle Ages. Others include the nunnery after which the bridges get their name, a house of canons on the Bury Road, and two friaries, one beside each bridge.

In the eighteenth and nineteenth centuries the town was still of importance. Assize Courts for Norfolk were held here, hence the still

surviving prison building – and the site of the public hangings north of the castle. The social calendar centred around the theatre in White Hart Street, and the coaching inns that once flourished along the main street remind us that the town was an important staging post on the main road from London to Norwich. The railway came in the 1840s and the town once boasted two railway stations.

Some great names are associated with Thetford, and have given it an extraordinarily cosmopolitan feel. Thomas Paine was born here in 1737. He wrote one of the most important of all radical books, *The Rights of Man*, but was no armchair socialist, taking a part in two revolutions – in America and in France. His parents are buried in the churchyard of St Cuthbert's but any gravestone has long gone.

Another personality of whom the town is proud is the Maharajah Duleep Singh, exiled by the British from his own country in 1849, when he was only ten years old. He lived in nearby Elveden Hall, where several of his own children were born. They included Prince Frederick, who bought an old house in Thetford and gave it to the town in 1921: this is now the Ancient House Museum.

Another family of colour was the Minns family, Allan, Pembroke and Ophelia, born in the Bahamas and resident in the town for many years, the two brothers being both medical men. Allan Minns was mayor of the town for two years 1904-6, and gives Thetford a unique claim to fame – the first town in all Britain to elect a black mayor.

Thetford played a major role in both wars, armaments being manufactured at Burrell's the traction engine works. Tanks were made on Breckland in the First World War and there are still reminders of the town's role in the 1939-45 war – pillboxes and spigot gun points. Breckland hosted many nationalities in the war – Poles, Czechoslovaks, Indians and Americans all lived in the area and played their part in the defence of freedom. The town will always be associated with the BBC comedy *Dad's Army*, made here and now commemorated by a museum and statue.

The town changed character again after the war, with designation as a London overspill town and continual expansion ever since: as I write, another 6,000 houses are planned. Many nations are represented amongst the newcomers, Poles and Portuguese above all, whose shops and whose languages add enormously to the diversity of the town centre. Thetford has been like this for at least a thousand years – long may it continue.

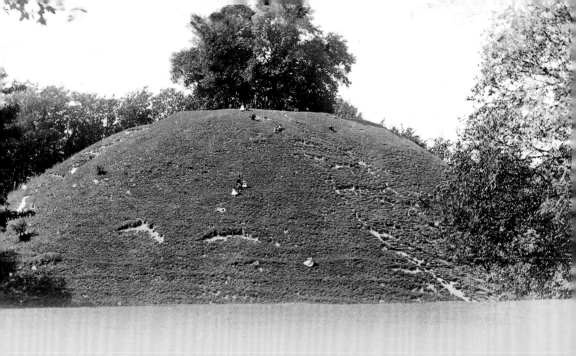

CHAPTER 1

Castle, Monastery and Church

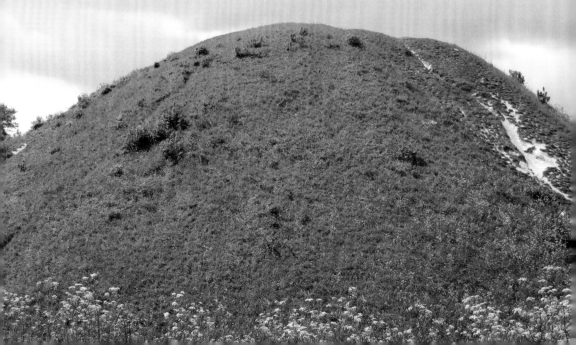

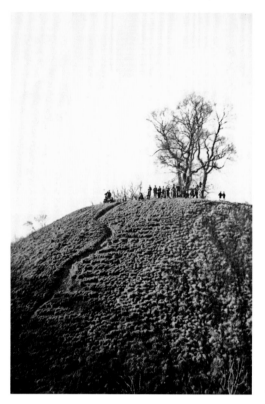

Thetford Castle Mound
The castle really consists of two structures, an Iron Age hill fort of about 500 BC and a mound – the second-highest in Norfolk – erected over 1,000 years later, very soon after the Norman Conquest of 1066. In the 1820s, Leonard Shelford paid for trees to 'beautify' the mound. The area became a public park in 1908 and Shelford's trees have been cleared from the mound in the interests of conservation.

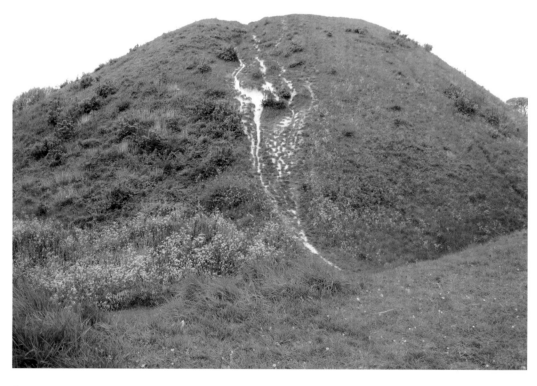

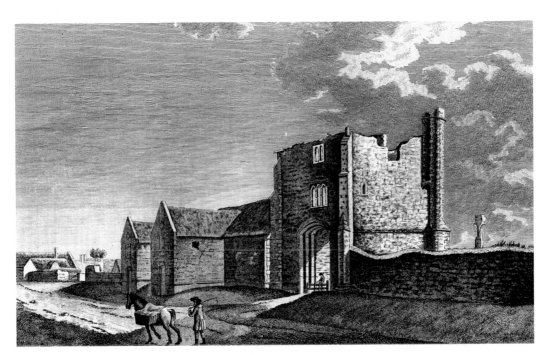

The Cluniac Priory of St Mary

The importance of Thetford in the Middle Ages is shown in the number of churches and monastic houses in the town, the remains of many of which survive. The largest monastery is that of St Mary, built in the early twelfth century by a local man, Roger Bigod. It was originally built south of the river in 1104, but was transferred to its present larger site in 1107, Bigod dying within a week of laying the new foundation stone.

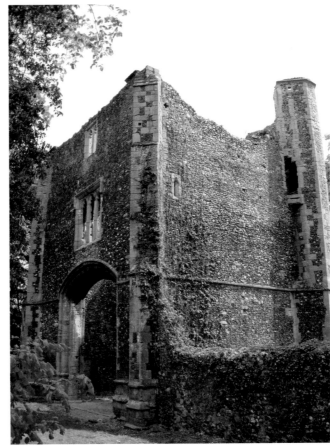

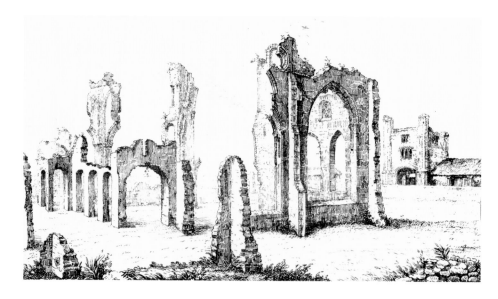

The Priory Church

The heart of any monastery is its church, and the church building forms the most impressive part of these ruins. Like all monastic houses, the priory was dissolved in the 1530s by King Henry VIII. It became a quarry of building material: many fragments of carved stone have been re-used in later buildings in the town. Have a look at King's House and see how many pieces of finely-carved limestone you can see in its walls!

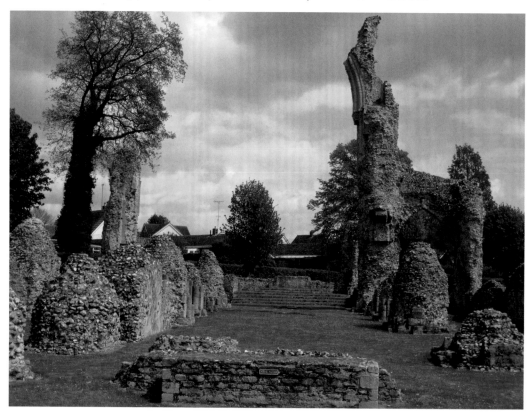

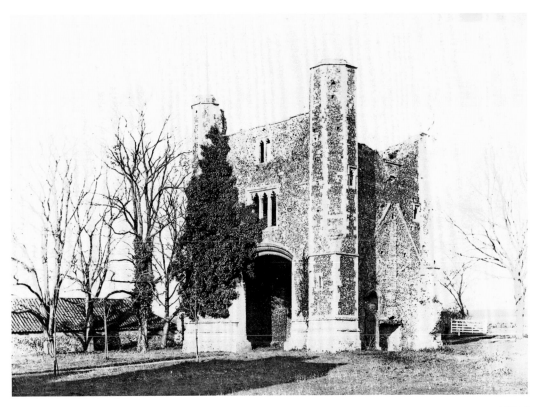

The Priory Gatehouse

The gatehouse is still a most impressive building, often missed by visitors as it stands at a distance from the main group of ruins. Monks needed walls and gatehouses for protection, but these defences were not always effective. In 1313, a mob broke into this priory: some of the monks fled into the church for sanctuary but were pursued by the gang and murdered in front of the high altar!

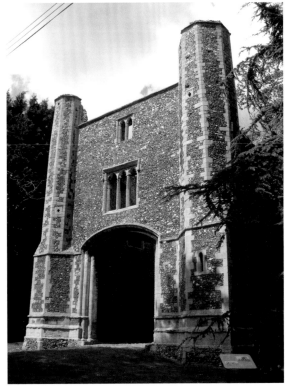

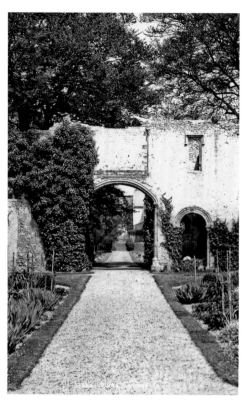

The Prior's Lodgings

The head of the monastery was the prior. He was an important man and had his own house, with adjoining buildings. The buildings became a private house when the monastery was dissolved. At the time of the historic photograph, the area in front of the Prior's Lodging was the kitchen garden of Abbey House. The ruins of the priory are now in the care of English Heritage.

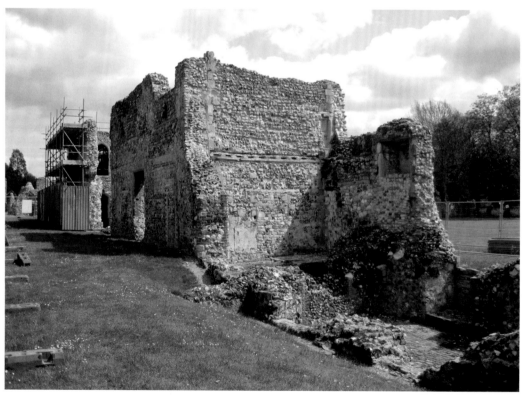

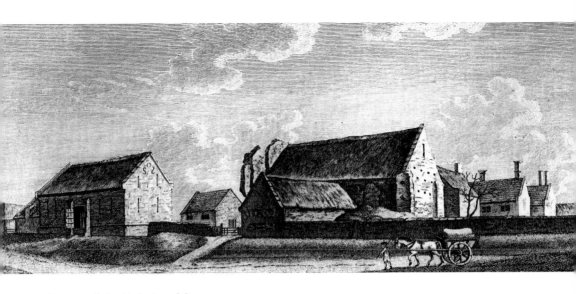

Canons of the Holy Sepulchre

The Canons, on the Brandon Road, was another monastic house and a very unusual one: founded in 1139, it belonged to an order established to help pilgrims travelling to the shrine of the Holy Sepulchre in Jerusalem, built on the supposed site of Jesus' burial. The founder was William de Warenne, who himself died in what is now Turkey on his way to the Holy Land in 1148: Thetford has had multi-national links for centuries.

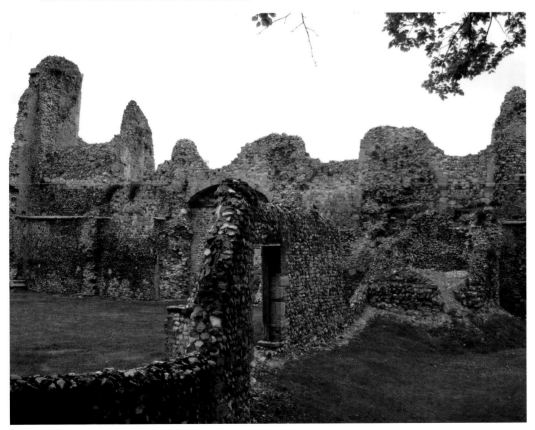

11

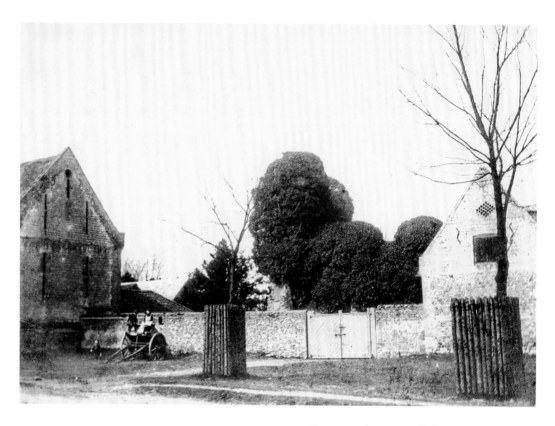

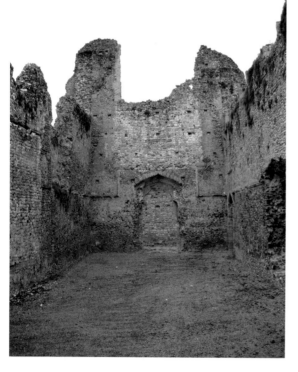

Barns on the Canons' Site
The canonry was dissolved in 1536 and the structures were soon converted into farm buildings, with the church becoming a barn: the site is now in the care of English Heritage. Very much smaller than the Cluniac priory it is worth a look, as the only surviving building in Britain of this order of canons: the church building still stands tall and there is a helpful information board.

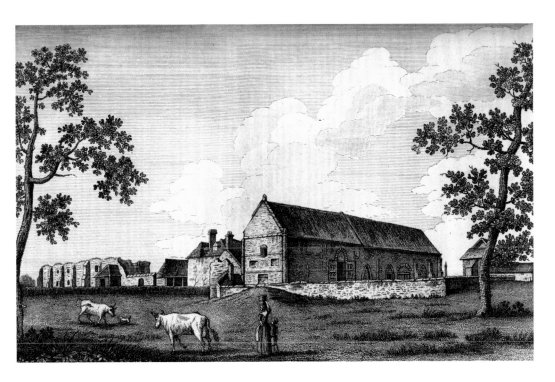

Nuns and Birds

Originally a house for male monks, this building became a nunnery in about 1176: they were supplied with food and drink from their parent house at Bury St Edmunds. Nearby Nuns' Bridges are named after the ladies who lived here for 350 years. The buildings became a farm at the Dissolution but have now been taken over by the British Trust for Ornithology, who have converted the old church building into their main offices and research centre.

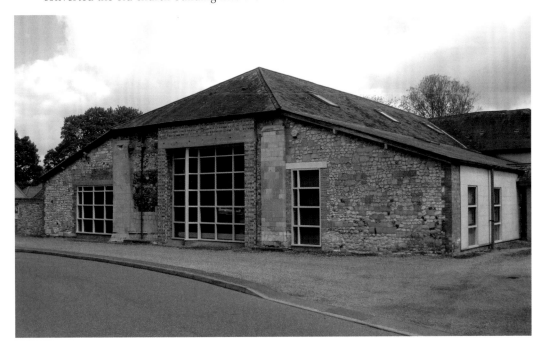

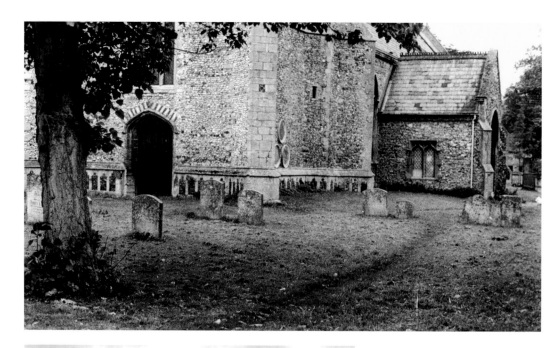

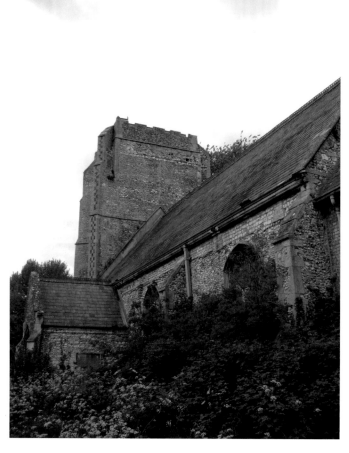

The Church of St Mary
There were about twenty churches in Thetford in the Middle Ages, three of which continued in use until recent times: however only St Cuthbert is now used for worship. This is St Mary on the south side of the river. It became redundant in 1975 and is in a very poor state of repair: at the time of writing its future is uncertain. Hopefully a new use will soon be found for this ancient building and its surrounding churchyard.

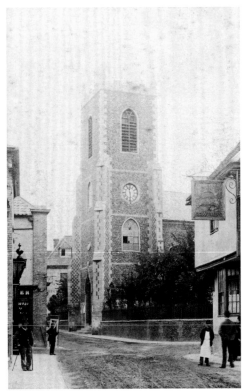

The Church of St Peter

This is the most prominent of the Thetford churches standing above the central crossroads of the town where White Hart Street, King Street, Bridge Street and Minstergate all meet. The tower, with its doorway directly into the street was rebuilt in 1789. The church is redundant, but, unlike St Mary, it is still lovingly cared for.

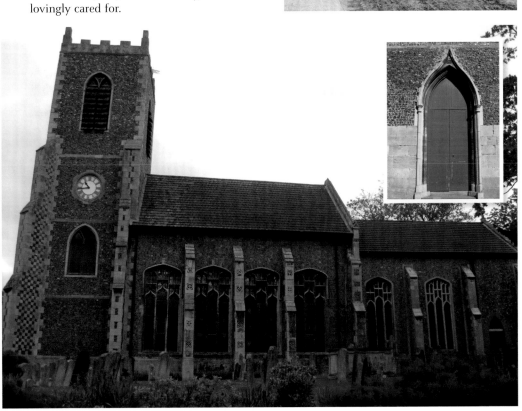

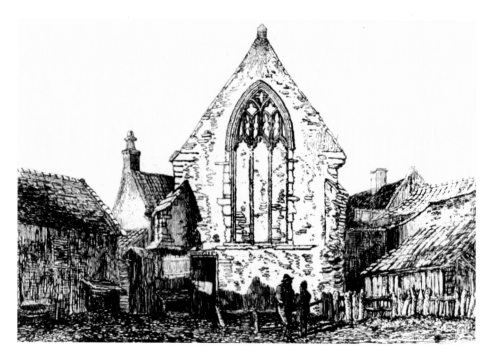

St Giles' Church and Street

St Giles was one of the many churches in Thetford that ceased to be used at the Reformation five centuries ago. As the historic image shows, it was still a prominent ruin in the eighteenth century, but it now survives only as a street name. It was behind the building now 'Tall Orders': if you look carefully at the lower part, especially the corner, you can see pieces of white limestone from the old church: there is nothing new about recycling!

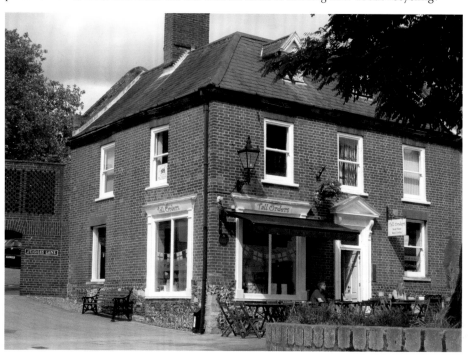

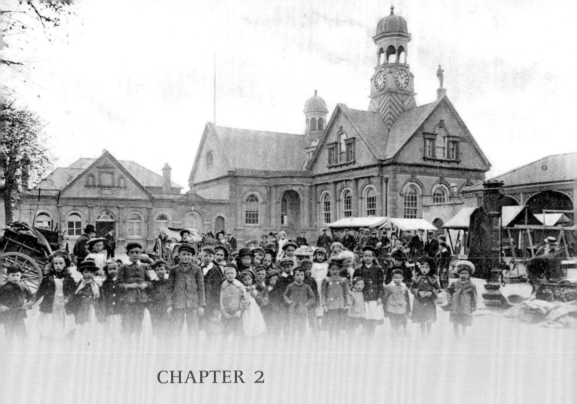

CHAPTER 2

The Heart of the Old Town

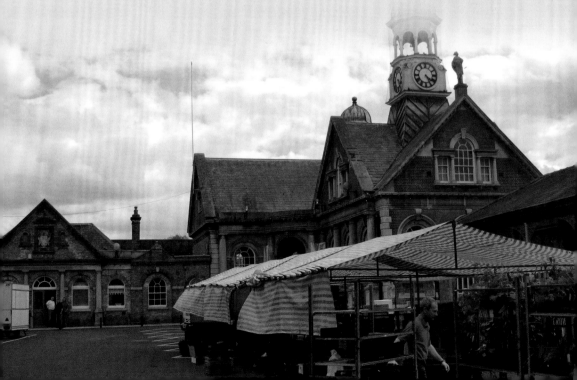

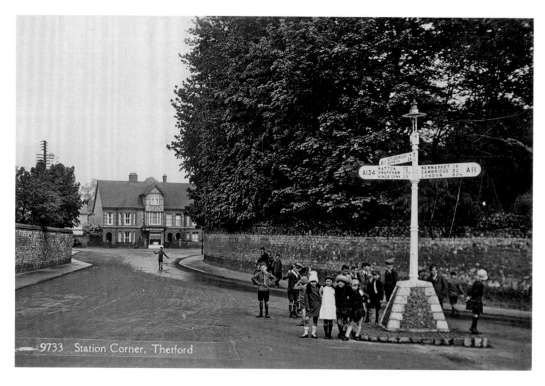

9733 Station Corner, Thetford

At the top of White Hart Street

One reason for Thetford's importance is that it is on the main road between London and Norwich: for centuries the traffic, on the road now known as the A11, passed right through the centre of town, as the sign in the historic photograph shows, running along White Hart Street and crossing the Town Bridge. The character of the centre of Thetford changed forever in 1968 when the main traffic was diverted along a new road with a new crossing over the river.

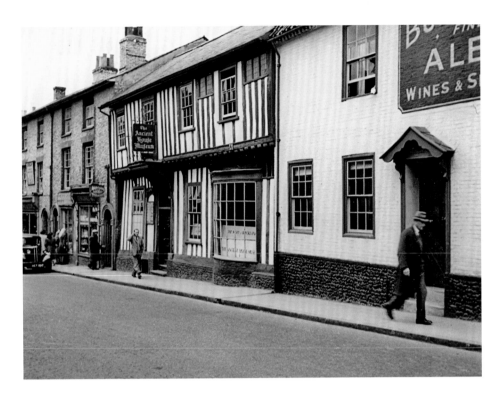

Thetford Ancient House Museum

This is a wonderful museum with many fascinating stories to tell about the history of the town: every resident and visitor should spend some time here. The house itself is a treasure of the late fifteenth-century, but its history was not appreciated until 1867 as the timber frame had been covered in many layers of plaster. The charming bow window is a later addition to the old house, dating from about 1800.

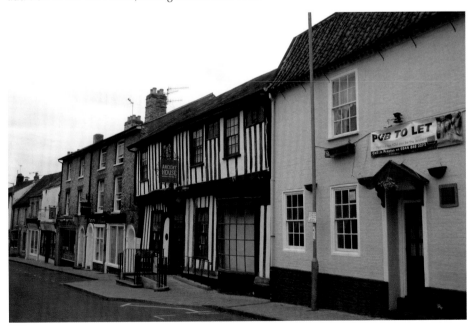

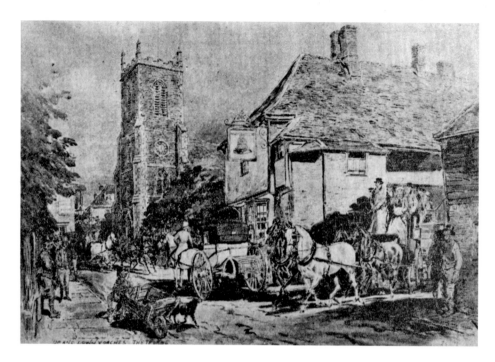

Coaching Days

In the days when Thetford was on the main route to London there were three great coaching inns along the main street. Two have now gone: the White Hart closed early in the twentieth century and the Anchor at the end of it. The Bell, however, continues to flourish: it is well over five centuries since it was first recorded in 1493. It was always the largest of the three, and in 1796 the then landlady, Betty Radcliffe, was supposedly the sole owner of post-horses in Norfolk.

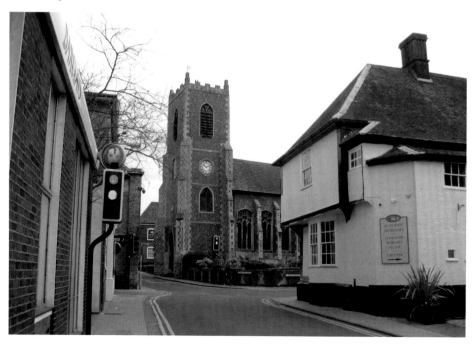

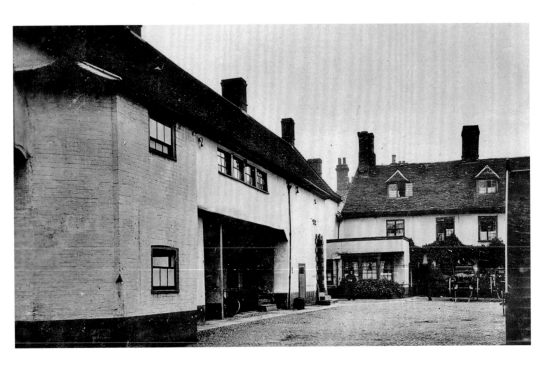

The Coaching Yard of the Bell Hotel

The long range to the left dates from the fifteenth century and is the oldest part of the building: there is a fragment of wall painting of that date inside. The entrance for coaches from King Street has been glazed over and now serves as an entrance. The range to the back was built in the sixteenth century: further buildings have been added to the hotel in the second half of the twentieth century to meet contemporary needs.

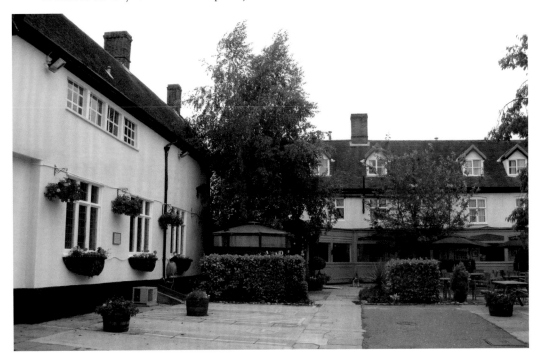

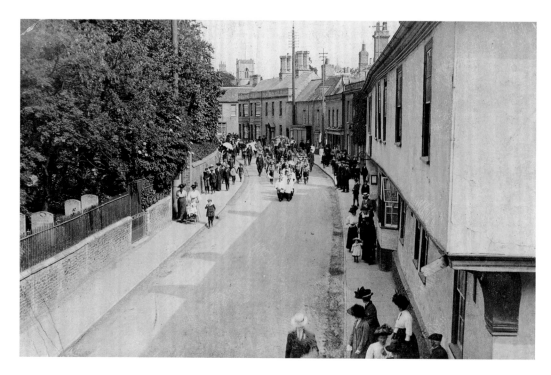

The West End of King Street

King Street is the main shopping street in today's Thetford and most of its buildings are modern. This end, however, is little changed. On the right is the long range of the Bell Hotel, with its projecting upper storey, on the left the churchyard of St Peter's. In the historic photograph a grand funeral procession is taking place, the hearse preceded by a group of Boy Scouts.

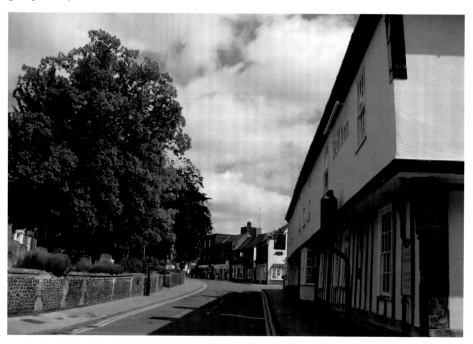

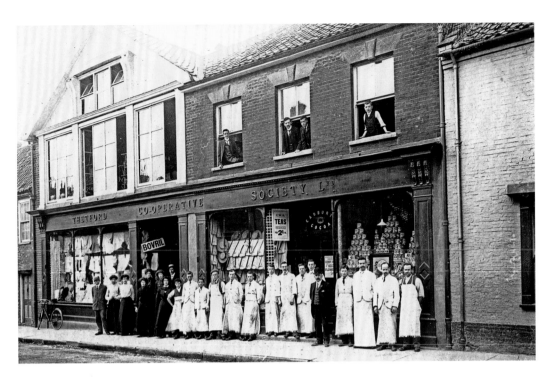

Thetford Co-op

In the early twentieth century, the Thetford Co-operative Stores had its main shop at 10-14 Guildhall Street, advertised as 'grocers, drapers, house furnishers, boot and shoe dealers, outfitters, milliners etc'. It had a branch on the Bury Road and a bakery on St Nicholas' Street. The staff line-up for the historic photograph shows just how many employees a large shop would have had a century ago.

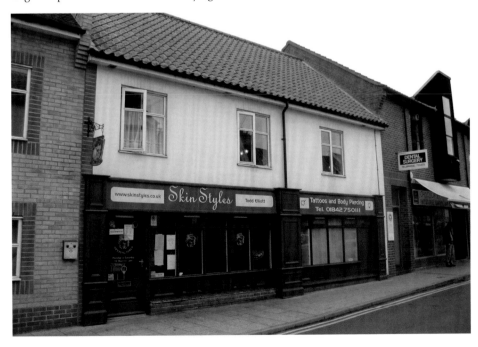

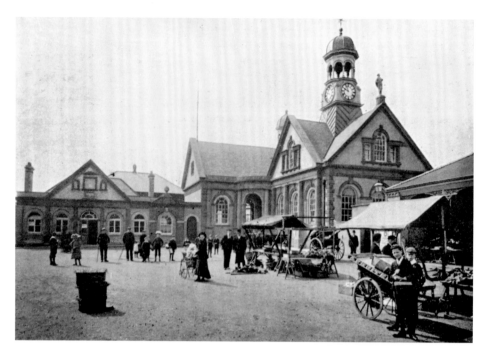

Thetford Guildhall

There has been a Guildhall on this site for centuries but the photographs show the building as rebuilt by H. J. Green in 1902 – it cost £10,000 to build! However the statue of Justice on the roof is from the older building, dating from about 1690. Thetford Market was moved to this site over two centuries ago in 1786. The older market had been beside the Castle for centuries: its site is preserved in the street name Old Market Street.

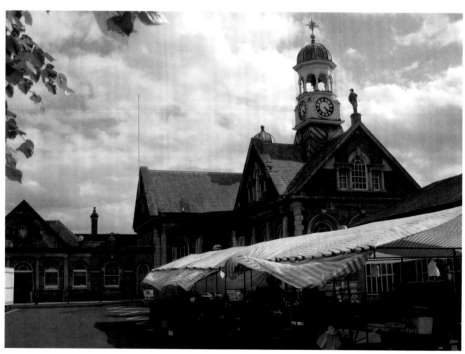

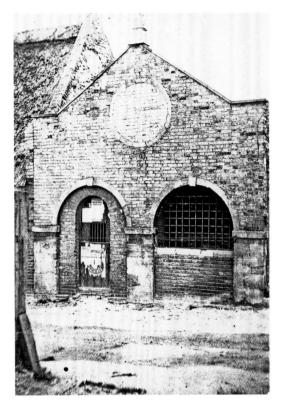

'The Cage'

The Cage was the town lock-up: drunks and petty offenders would be forced to spend a night here, and it contains the town stocks. It was moved across the road when the Carnegie Room was built as a public hall in 1967: at the time of writing the Carnegie itself is being demolished. The historic photograph shows the Cage on its original site, the gable in the image belonging to the Quaker chapel where Thomas Paine and his father worshipped.

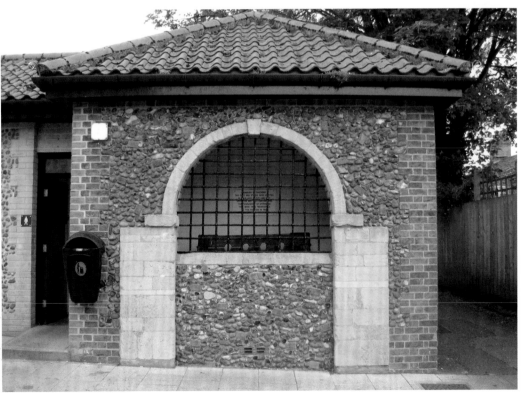

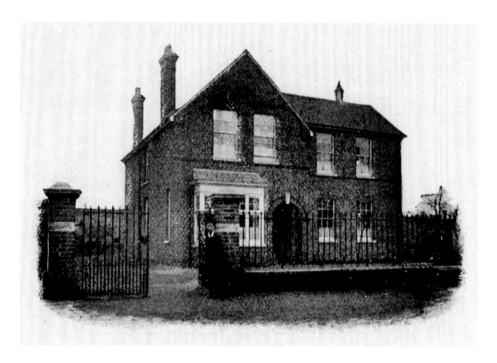

The Cottage Hospital

The Hospital was established in 1898, with the financial support of local citizens such as the Bidwells, the Thetford brewing family (whose buildings can still be seen opposite the Gaol). It was very small with just six beds and a cot: it was extended in 1923 as a war memorial. It continued to provide a vital service to the town throughout the twentieth century, but has recently closed: the nearest hospital is now in Bury St Edmunds.

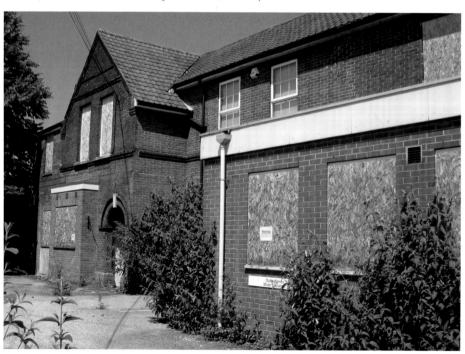

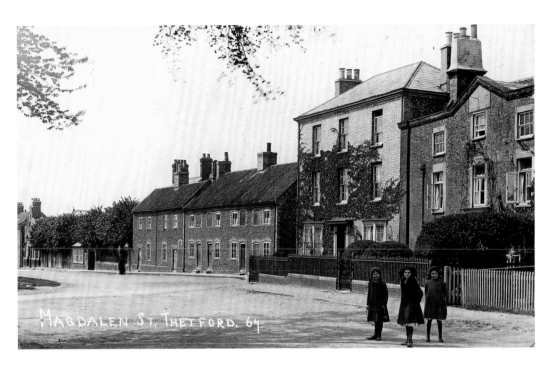

Magdalen Street

When Celia Fiennes visited Thetford in 1698 she thought it 'formerly a large place but now much decay'd'. This street runs off the corner of Market Square and displays a range of old houses, small cottages built out of the local flint, and large brick-built houses for the nineteenth-century middle class, with rooms for servants. These show that there was some wealth in the town whatever visitors thought.

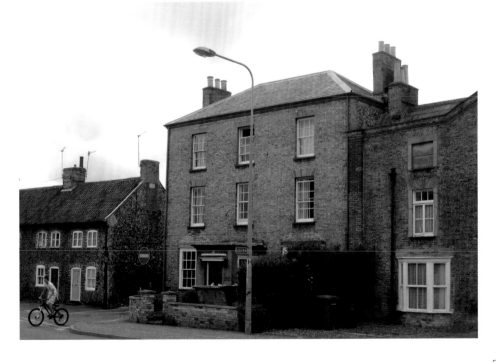

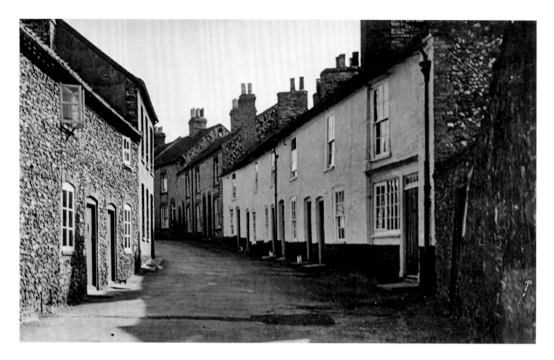

Old Housing and New

The historic photograph shows typical small Thetford cottages, built of flint or sometimes of chalk blocks, known as clunch, with front doors opening directly onto the street and with toilets at the back, often shared between several houses. Several thousand new houses have been built in the twentieth century, some as slum clearances but most for incomers to the town from London and elsewhere – and more are planned.

A CALENDAR

Of the Prisoners now in the Custody of the Sheriff of the said County, for Trial at the Lent Assizes, to be holden at Thetford, in the said County, on Wednesday, the 16th day of March, 1831, before the Honourable Sir Stephen Gazelee, Knight, one of the Justices of our Lord the King, of the Bench, and the Honourable Sir Edward Hall Alderson, Knight, one other of the Justices of our said Lord the King, of the Bench, Justices of our said Lord the King, assigned to deliver the aforesaid Gaol of the Prisoners therein being.

FELONS FOR TRIAL.

1 MATTHEW SMITH, aged 25, Committed August 10, 1830, by Right Hon. Lord Suffield and J. T. Mott, Esq. charged on the oath of Sarah, the wife of John Brooks, of Southrepps, with having, in the afternoon of the 1st of this month, ravished her.

2 WILLIAM SCRAGG, aged 26, Committed October 12, 1830, by W. W. Lee Warner, Esq. charged on the oath of Money Sendall, of Mattishall, shopkeeper, with having, on the 6th of this month, broken into a certain building within the curtilage of his dwelling-house, and stolen thereout one copper boiler and various other articles.

3 JOHN GOULBY, aged 29, Committed October 14, 1830, by Richard Gwyn, Esq. charged on the oath of Mary Poll, of Shelton, widow, with having, on the night of the 9th of this month, burglariously broken open her dwelling-house, and stolen thereout about sixteen pounds seventeen shillings in money, a trunk, and a fustian pocket.

4 GEORGE READ, aged 35, Committed October 15, 1830, by the Rev. Temple Frere and Wm. Manning, Clks. charged on the oath of Robert Scales, of Burston, farmer, with having, early on the morning of the 4th of July last, broken into his house, and stolen thereout silver spoons and other articles, or receiving some of the same goods, knowing them to have been stolen; also charged on the oath of James Moore, of Diss, gentleman, with breaking into the house of Martha Moore, in the night of the 23d of September last, or early on the following morning, and stealing silver spoons and other goods, or receiving some of the same, knowing them to have been stolen; also further charged on the oath of John Coe. of

The Town Gaol

Thetford was the only place in Norfolk apart from Norwich where the Assize Courts were held. These courts tried the major crimes and could sentence people to death – three people were publicly hanged on one day in Thetford in 1824, one for the crime of stealing sheep! Such a town needed a gaol, and this was last rebuilt in 1816. The Assizes stopped coming to Thetford in the early 1830s. You can still see original window bars in the cells on the top floor.

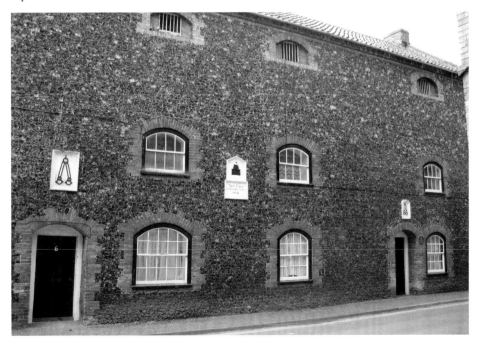

CHAPTER 3

A River Runs Through It

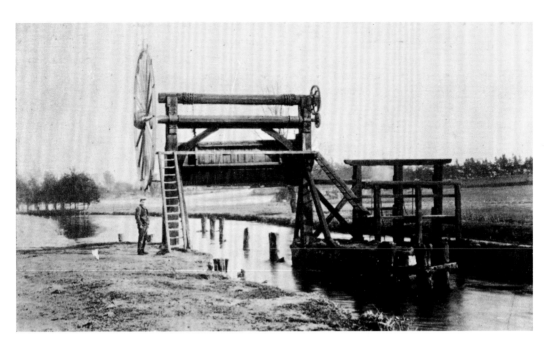

Staunches along the River

The Little Ouse river runs right through Thetford, where it is joined by the Thet, and eventually reaches the sea at King's Lynn. It is a key element in the history of the town. The river below Thetford was made navigable by staunches, the Fenland equivalent of locks. Unlike a lock, a staunch had a single gate to hold up the water: it could be raised by turning a large wheel, and the boat would shoot forward with the rush of water.

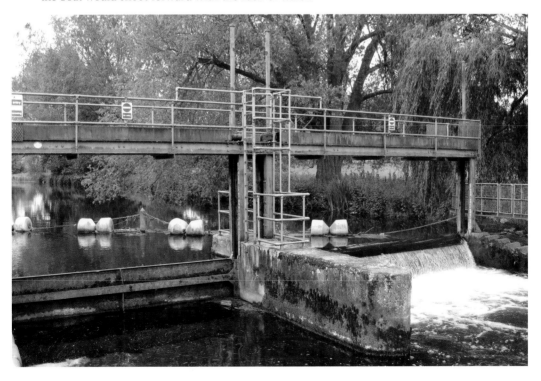

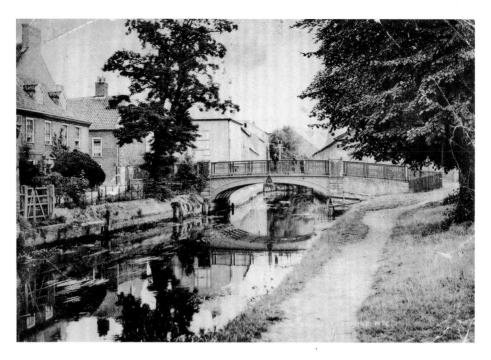

The Town Bridge from the Haling Path

Much of the town's trade went along the river, often in barges hauled by horses: the path beside the river seen here is called the Haling Path, the same word as hauling. The path can still be followed for most of the nine miles between Thetford and Brandon. An Act for making the river navigable was first passed as long ago as 1669.

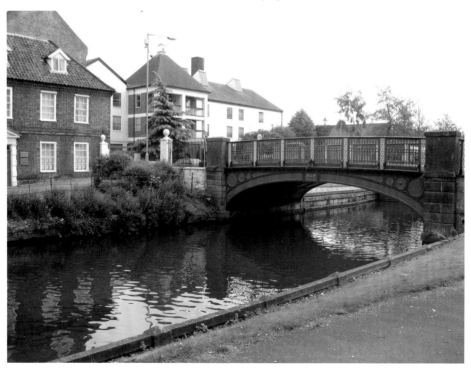

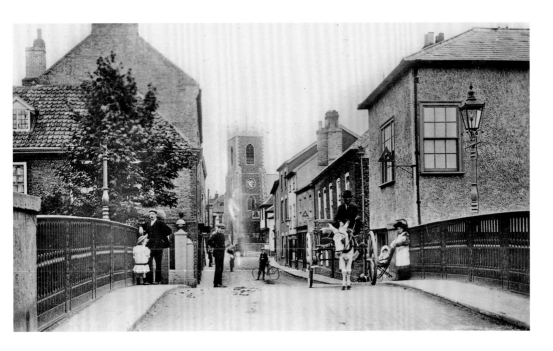

Thetford Town Bridge

There has been a bridge here for centuries. The present cast iron bridge was designed by Francis Stone, the Norfolk county surveyor and built in 1829: you can see the date inscribed on both sides of the bridge, for example from the site of the new Captain Mainwaring statue. It is almost impossible today to imagine that until 1968 this was the main road between London and Norwich.

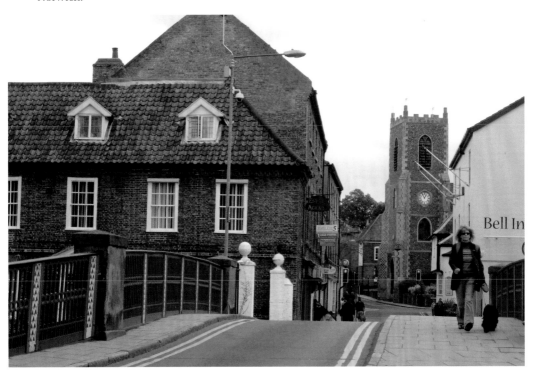

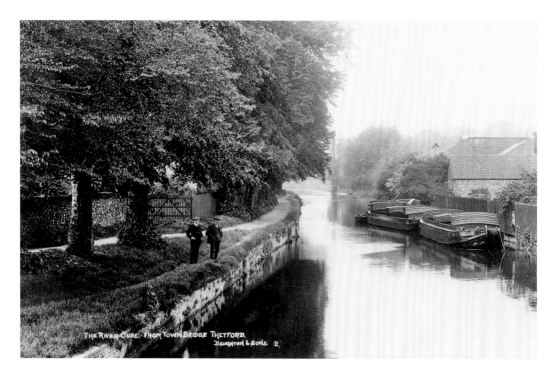

The River from the Bridge

Barges or lighters were loaded and unloaded at warehouses along the river, none of which survive in the modern town. Typical lighters were about 42 feet long, about 9 feet wide at bottom and 10 feet at the deck. They had to have a very shallow draught as the river was only two feet deep, and were often worked in groups of about five chained together. Today the only ship in town is a floating restaurant.

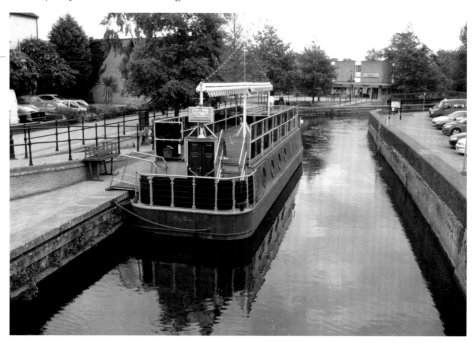

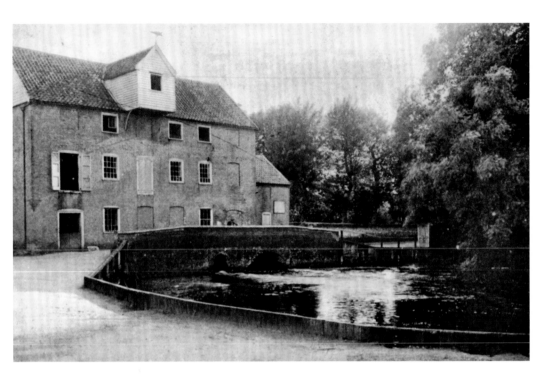

The Coffee Mill

This lovely watermill has a misleading name: the building was used for storing coffee for a short time in the 1930s, but it was never used for grinding it! The present building is early nineteenth century but there have been watermills at Thetford for a thousand years. Two are mentioned in the Domesday Book of 1086: one belonged to the Bishop of East Anglia, who was based in Thetford until he moved to Norwich in 1096.

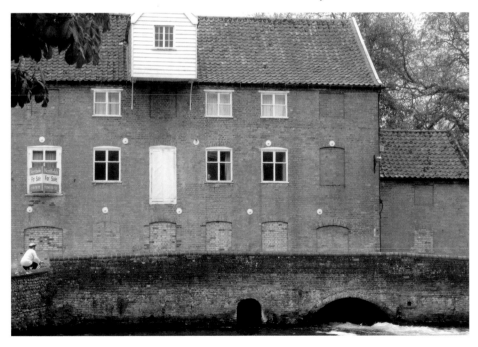

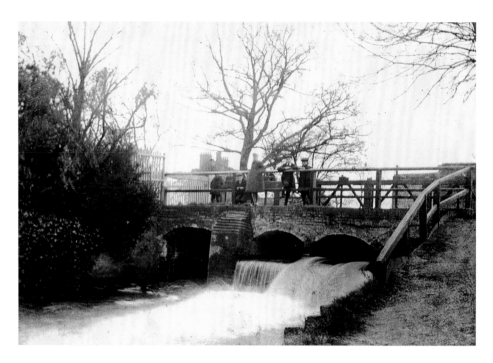

Along the River: The Waterfall

The walk from the Town Bridge to the Nuns' Bridges is one of the most pleasant in Thetford, much of it between the two rivers, the Thet and the Little Ouse. The complicated sequence of streams and waterfalls show that there was once a major industrial complex here (see Patent Pulp Paper, below), but it is now given entirely to nature.

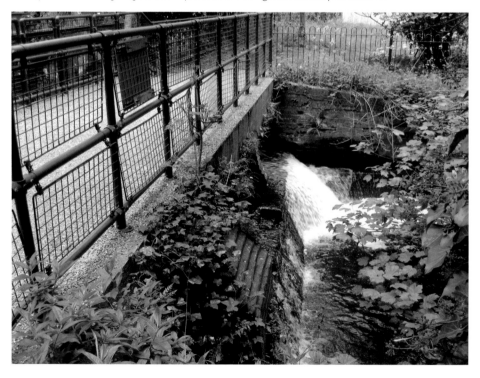

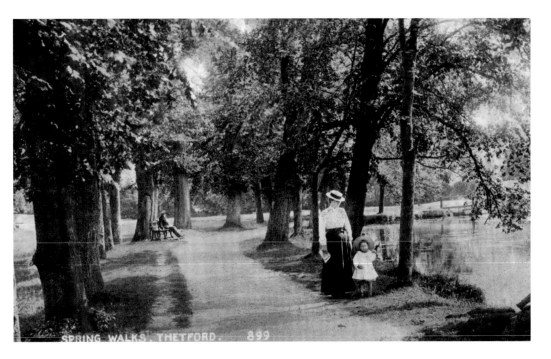

The Spring Walks I

The walk was first constructed in 1818 to go with Spring House. The Little Ouse rises in Lopham Fen and runs westward. The Waveney also rising in Lopham Fen runs eastward, originally reaching the sea at Yarmouth: the two rivers form the boundary between Norfolk and Suffolk for most of their courses – and almost make Norfolk an island: three centuries ago there was a plan to canalise the rivers to complete this process!

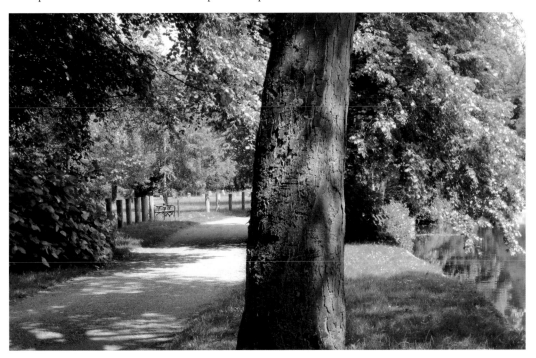

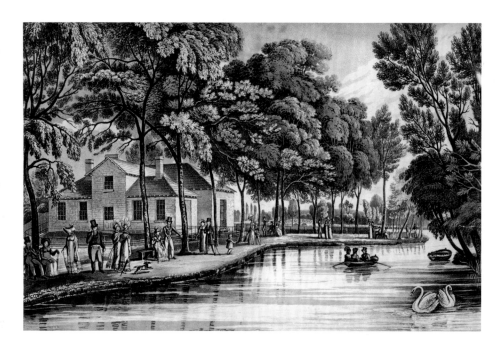

The Bath House

The Duke of Grafton laid the foundation stone of Spring House which was built as a Pump House in 1819: it was an early attempt by local entrepreneur John Burrell Faux to develop a spring containing iron salts that bubbles up here into a Health Spa, like Bath or Harrogate. The venture failed to catch on and the Pump Room closed after twenty years: it has been a private house ever since.

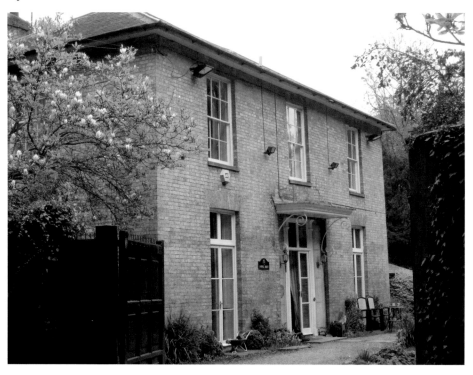

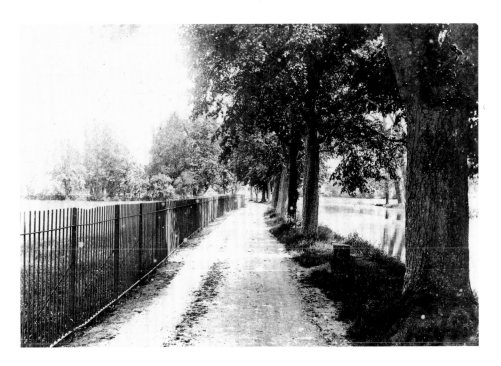

The Spring Walks II

Thetford has been extremely fortunate in the generosity of its citizens who have given large parts of land to the town for the enjoyment of its citizens and of visitors. The land to the left of the fence seen in both pictures was originally known as Lammas Meadow and became known as Spring Meadow after the development of the adjoining Pump House. In 1943, it was given to the town by Sir William Gentle and became the Lady Gentle Memorial Meadow.

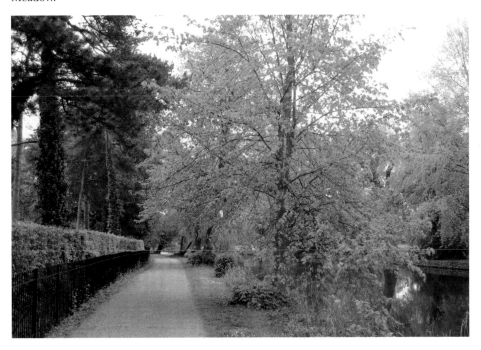

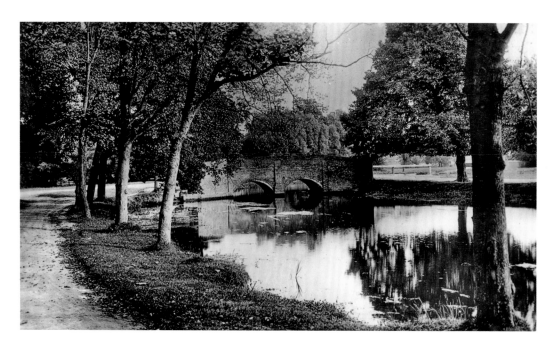

Towards the Nuns' Bridges

There are actually three bridges here, crossing the Little Ouse, the Thet and a third river known as the Thet Stream. The bridge seen here is the southernmost of the three. This one and the northernmost bridge are late eighteenth century and each has two elliptical arches. The central bridge is early nineteenth century and has a single semi-circular arch.

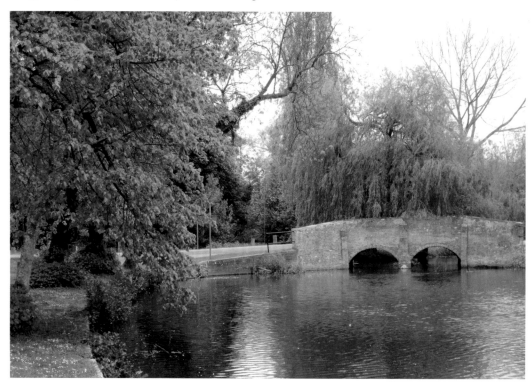

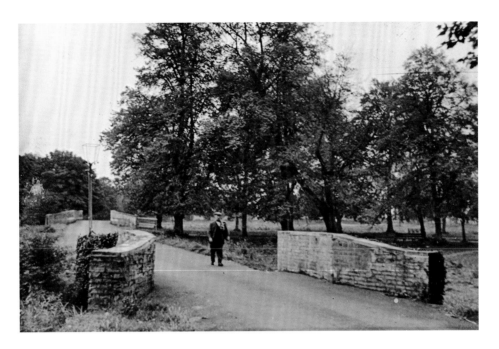

At the Nuns' Bridges I

This is the heart of ancient Thetford: people have been crossing the river here for at least five thousand years. The prehistoric track way known as the Icknield Way crossed the rivers here by means of the ford that gave its name to Thetford, and an Iron Age fort, now Thetford castle, protected the crossing. The bridges are mentioned in a document of 1392: at one time there was a ducking stool for scolds here.

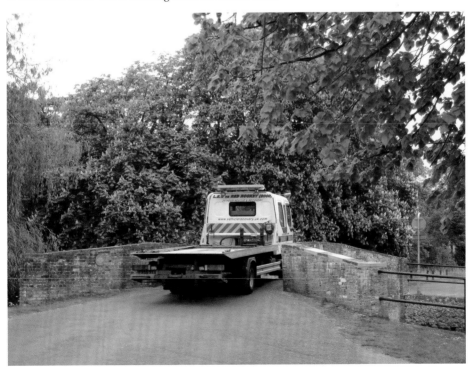

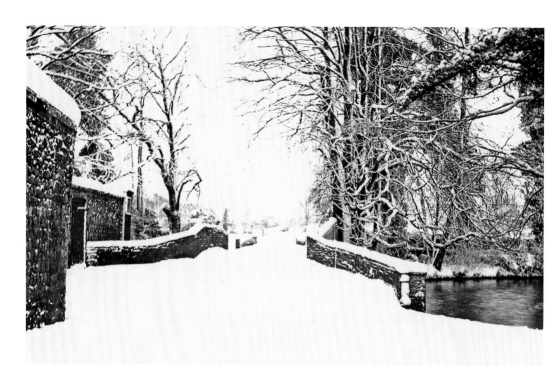

At the Nuns' Bridges II

Both ends of the bridges were once dominated by religious houses, the nunnery to the south and an Augustinian friary to the north. The large house now seen on the north bank is Ford Place, once the home of the Fison family – famed for their fertilisers – and now a retirement home. In the grounds is 'Thetford's Secret Garden': lovingly tended by volunteers it is one of the most peaceful places in Thetford.

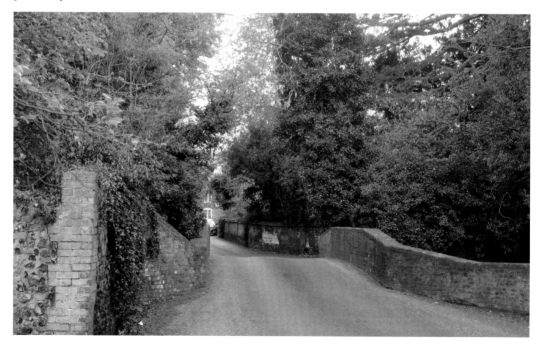

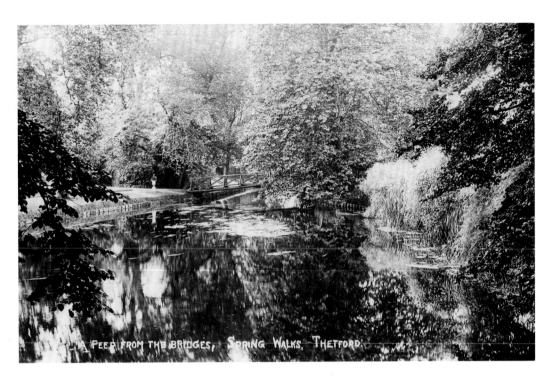

A PEEP FROM THE BRIDGES, SPRING WALKS, THETFORD.

A View from the Bridge

The walk from the Town Bridge to the Nuns' Bridges has been popular with Thetfordians for two centuries and there are now very pleasant walks further upstream through the woodland owned by the British Trust for Ornithology and managed for nature conservation: you can now walk all the way up to Melford Bridge.

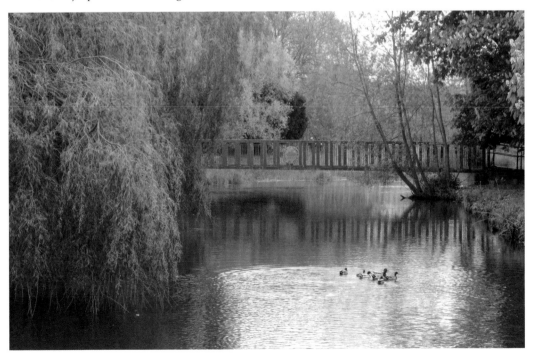

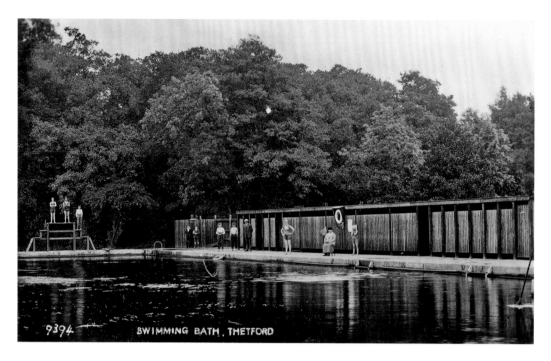

SWIMMING BATH, THETFORD

Thetford Swimming Baths

Thetford had several facilities which disappeared in the later twentieth century – but which the many thousands of newcomers to Thetford would surely appreciate today. One was the Palace Cinema on Guildhall Street, closed in 1985 after over seventy years and now a Bingo Hall. Another was the open-air swimming pool beside the river. Its concrete structure can be best seen today from the newly-built footbridge.

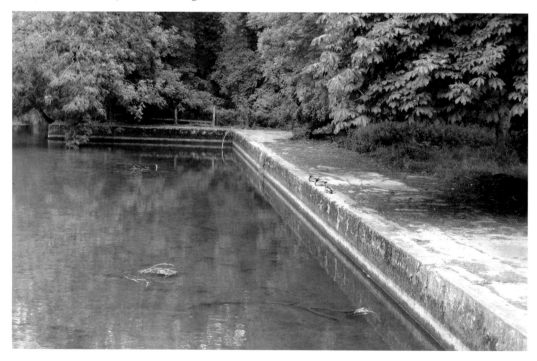

CHAPTER 4

Around the Fringe

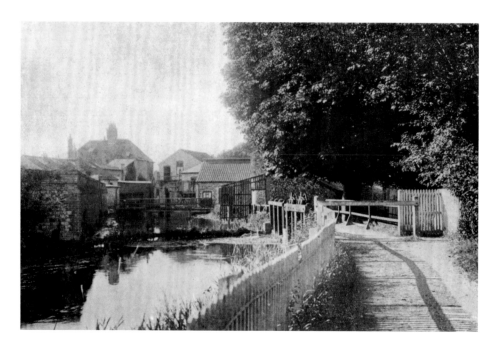

Patent Paper Pulp

Paper-mills were established here in 1797 on the site of an ancient watermill. In 1879, the Patent Paper Pulp Moulding company was established: it produced lightweight but extremely tough moulded bowls and related objects. Some of the produce of the firm, a favourite memory among older Thetfordians, can be seen in the Ancient House Museum. The last remaining buildings have been converted into a private house.

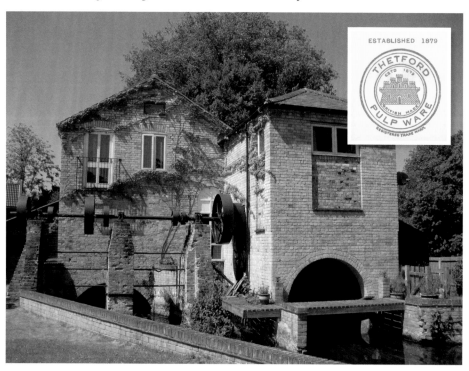

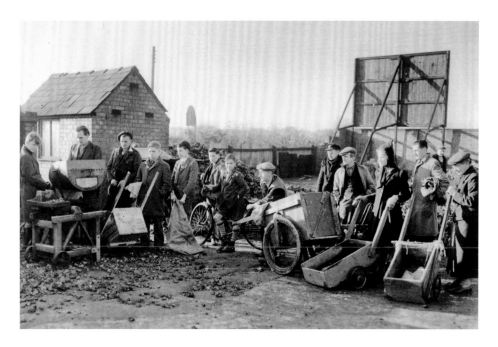

At the Gas Works

Gas came to towns much earlier than most people think. Thetford Gas Works was on the Bury Road and was originally a private company founded in 1845. The historic photograph shows a scene hard to imagine today: householders in 1951 queuing up for coke for their own homes during a fuel shortage. Only the house shown in the modern photograph survives of the gas works buildings.

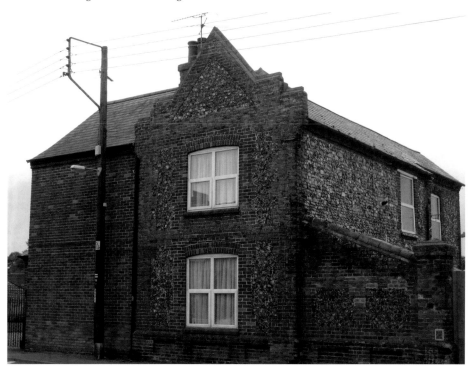

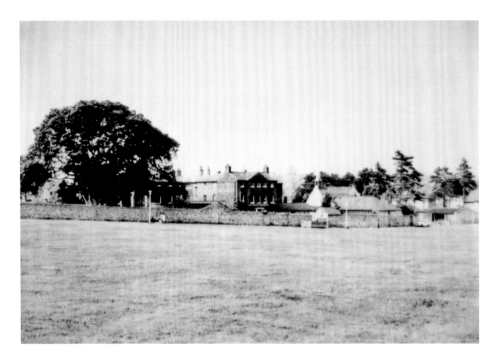

Thetford Workhouse

Victorian 'care' for the poor involved placing them in a workhouse: all the disadvantaged of the Thetford district including orphans, single mothers, the mentally and physically handicapped and the elderly would end up here. The workhouse was on the Bury Road: built in 1835 it closed in the 1930s and was demolished in 1978. Its boundary wall survives, now surrounding an estate of modern private houses.

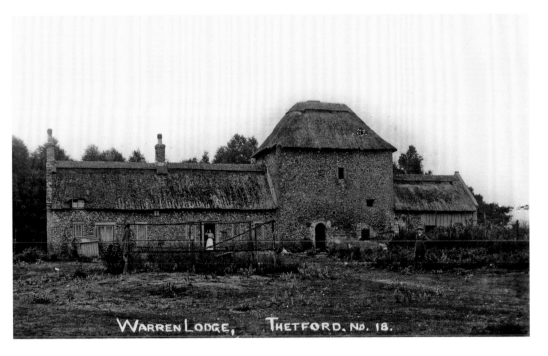

Warren Lodge I

Warren Lodge was owned by the Cluniac priory, and was a place for hunting parties to retreat inside if they came under attack. The word warren originally meant hunting in general rather than just rabbits: the very earliest document in the Norfolk Record Office, which dates from about 1090 and is addressed to the Bishop of Thetford, is about rights of warren: early kings and bishops were extremely keen on hunting!

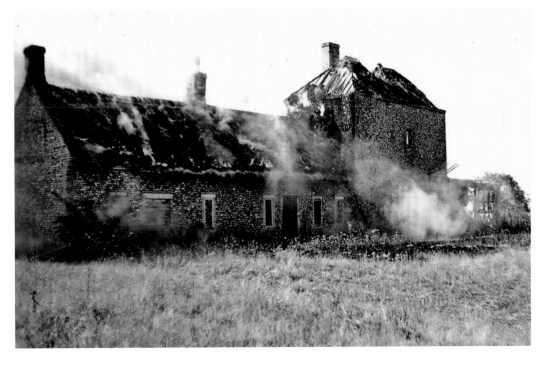

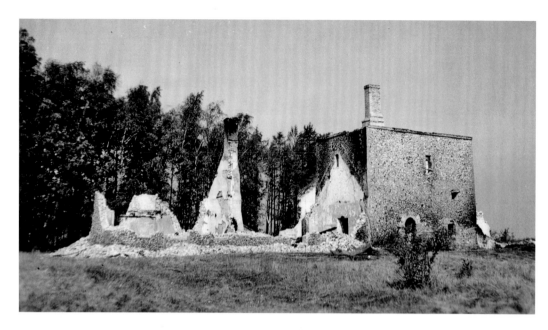

Warren Lodge II

In later years, the lodge was used for storing and guarding rabbits. Rabbits were worth stealing: in the Middle Ages, an East Anglian rabbit could fetch up to five pennies, the equivalent to two days' wages for a labourer! Two pictures on these pages were taken on 1 August 1935, when the building caught fire and was severely damaged. The remaining building is now in the care of English Heritage.

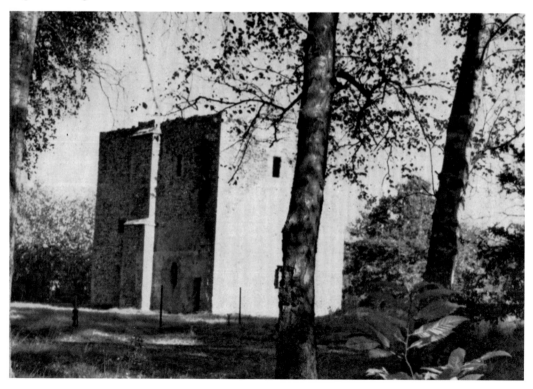

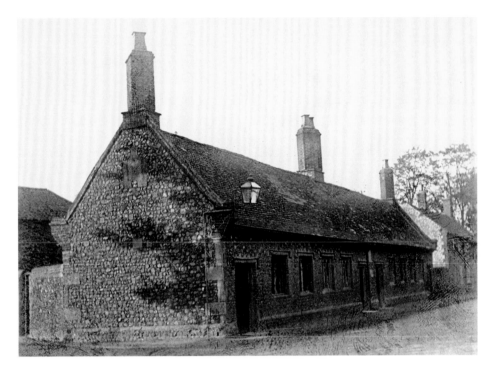

The Almshouses

In the Middle Ages, the many monasteries in Thetford helped the poor of the town. Sir Richard Fulmerstone who bought up much of the monastic property in the town left money in his will for the establishment of these almshouses for the elderly inhabitants of the town. He died in 1566 but the houses were not built until 1610: they were renovated in Victorian times and again in 1968.

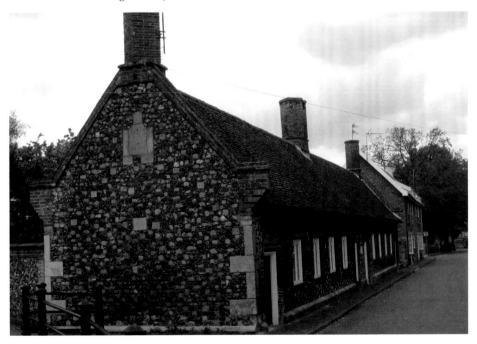

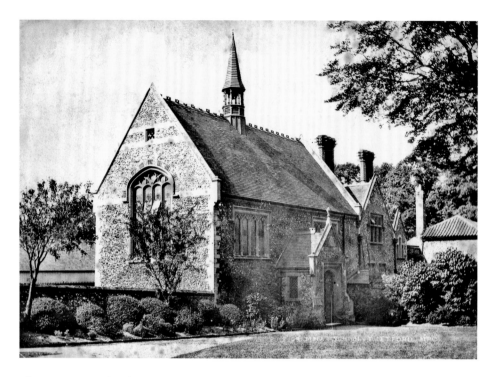

The Grammar School

The school boasts origins lost in the mists of history. The buildings incorporate parts of the Dominican friary founded by Henry, Duke of Lancaster, in 1335: these can be seen from the Haling Path. The earliest surviving school building was erected in 1575 under the terms of the will of Sir Richard Fulmerstone in 1566.

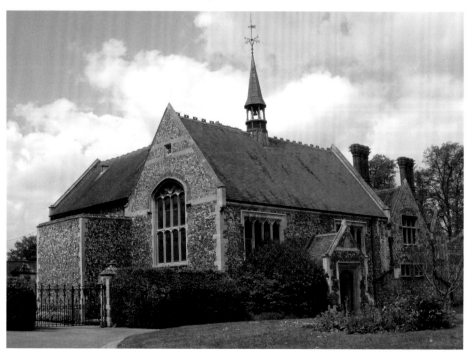

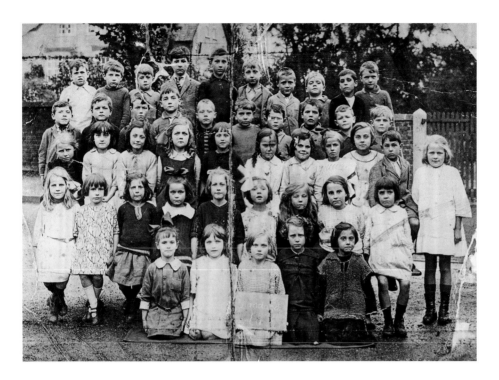

The Board School

The Board School on the Norwich Road opened in 1879 with space for 750 children, and was enlarged in 1906 to take a further 150 – large schools are not just a product of the later twentieth century! It was a typical Board School – boys, girls and infants each had their own section of the building, with its own separate entrance, classroom and playing yard.

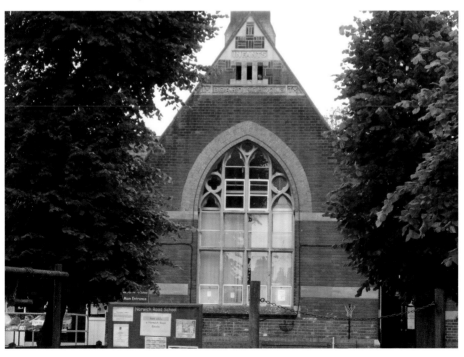

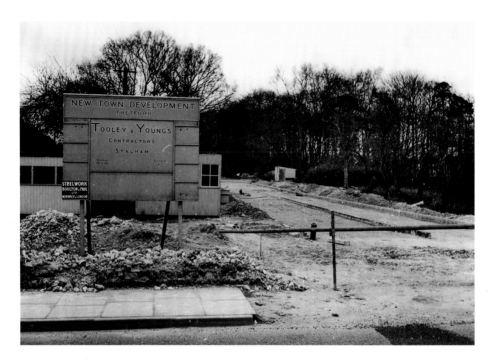

The Expansion of Thetford

The writer Virginia Woolf visited the town in 1906, writing in her journal, 'Often in London I shall think of Thetford and wonder if it is still alive.... No one would notice if the whole town forgot to wake up one morning.' Half a century later, the town woke up indeed: the first new housing estate was along the Bury Road, followed by the Redcastle Furze estate and the Abbey Farm estate, which alone has almost a thousand houses.

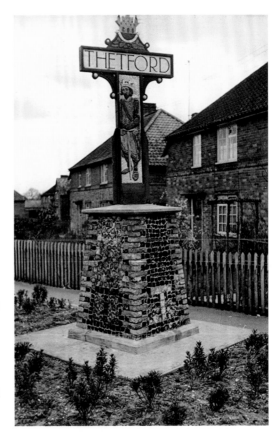

The Town Sign

The first town sign was erected in Newtown, where the London road entered Thetford. Boasting images of Swegn Forkbeard and Thomas Paine, it was designed by Harry Carter of Swaffham, a relative of the Howard Carter who discovered the tomb of Tutankhamun, and the creator of many Norfolk town and village signs. The sign has recently been redesigned on its original plinth.

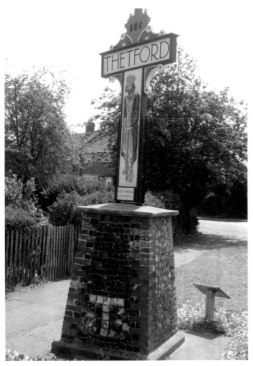

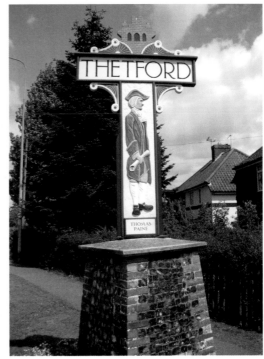

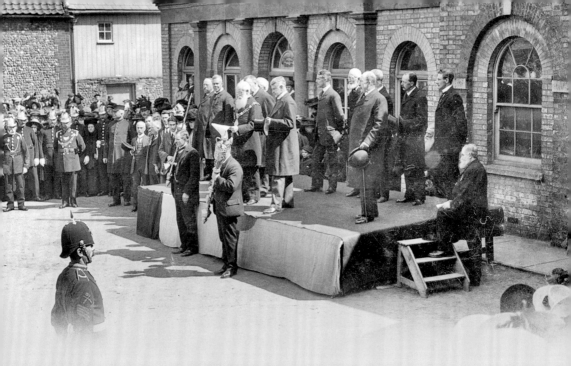

CHAPTER 5

Let Us Now Praise Famous Men

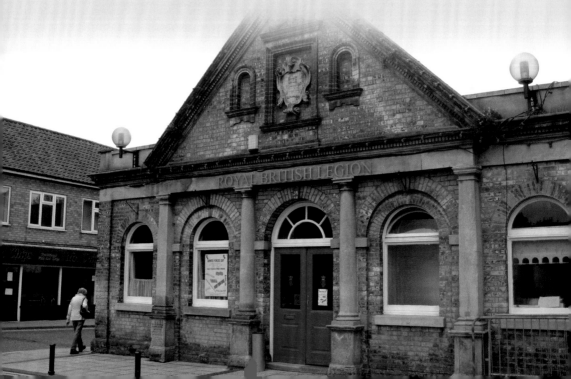

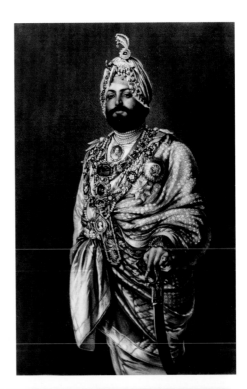

The Maharajah

The Maharajah died in Paris in 1893: he and several members of his family are buried at Elveden churchyard. Over the years, his significance to Thetford has grown and the district has become a place of pilgrimage. This culminated with the erection of the statue to his honour on Butten Island, with its inscription in two languages, formally unveiled by Prince Charles in 1999.

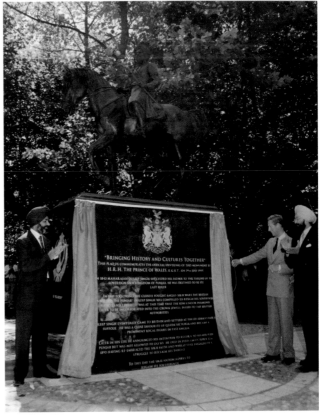

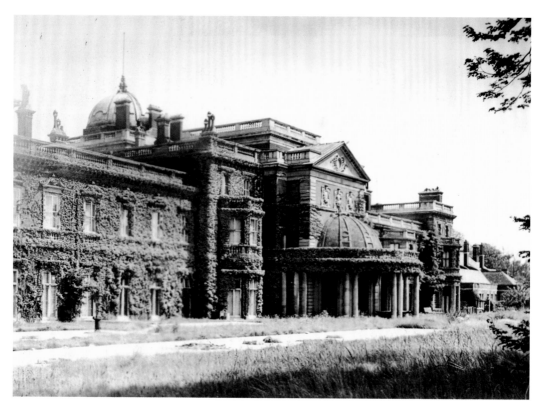

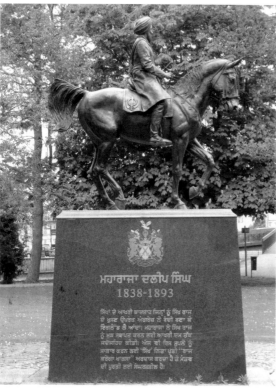

The Maharajah Duleep Singh

The Maharajah and his family brought much to the Thetford area. He was the last Emperor of the Sikhs, who was deposed by the British in 1849, and brought back to Britain. The Maharajah spent his exile at Elveden Hall just outside Thetford: he died in 1893. He is still venerated by the Sikh community, many of whom visit his statue.

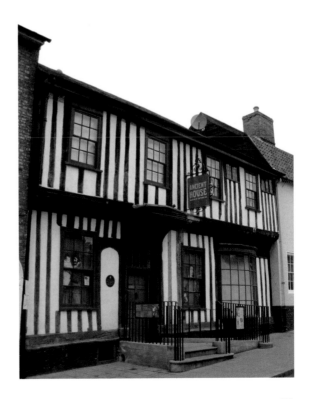

The Generosity of Prince Frederick
The Maharajah had several children, including Sophia who was an active suffragette, selling their magazine outside Hampton Court Palace! His son Frederick took a great interest in Norfolk history, collecting a large number of historic maps which are now in the Norfolk Record Office. He also bought this old house and presented it to the Corporation for use as a museum: Thetford is rightly proud of this family of incomers.

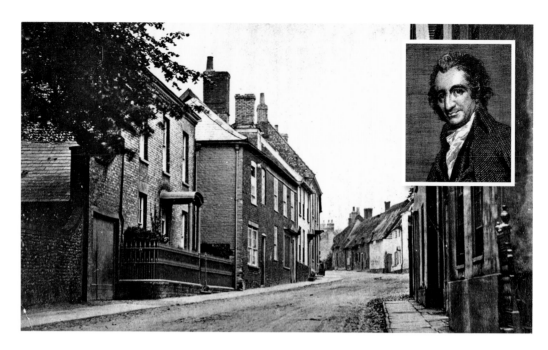

The Birthplace of Thomas Paine

Thetford is proud that one of the greatest radical writers of all time was born in the town: Thomas Paine (1737-1809). His book *The Rights of Man* is one of the most important contributions ever made to the struggle for human rights and liberties: it has been studied by hundreds of thousands of working men and women throughout the world. His birthplace was at the top of White Hart Street.

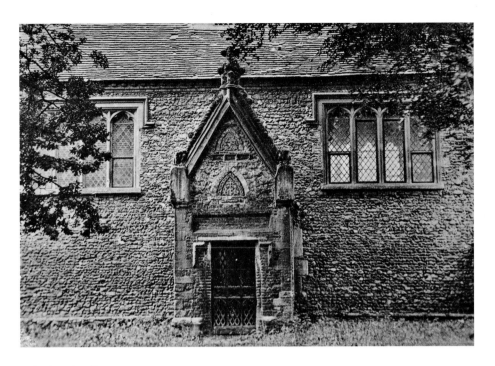

Paine's Schooling

Paine went to Thetford Grammar School; we can imagine him walking every day down White Hart Street and across the bridge (not the present one) to school. His teacher was the school usher, the Reverend William Knowles. Knowles had served on a man-of-war in his earlier life and it may well have been his stories that inspired Paine to go to sea after he left school, and eventually to start a new life in America.

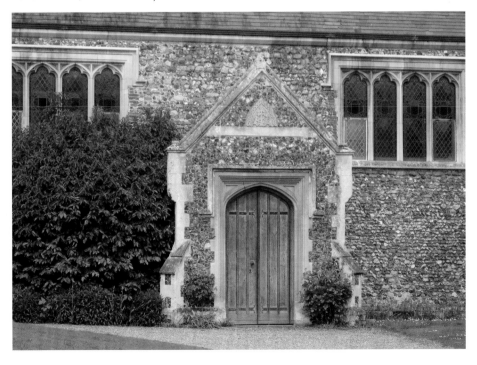

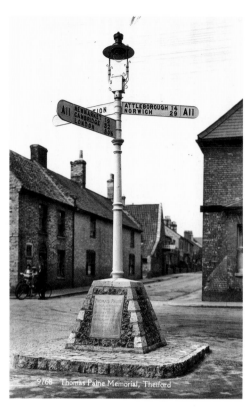
9768 Thomas Paine Memorial, Thetford

Thomas Paine Remembered

The first memorial to Paine in Thetford was a plaque on a lamp stand in the centre of the road, erected in 1909, exactly one century after his death. American Air Force men in the area in the Second World War erected a plaque in front of King's House. The present statue, designed by Charles Wheeler, was erected in 1964: it is made of bronze and was originally coated with gold leaf but this was replaced in 1973.

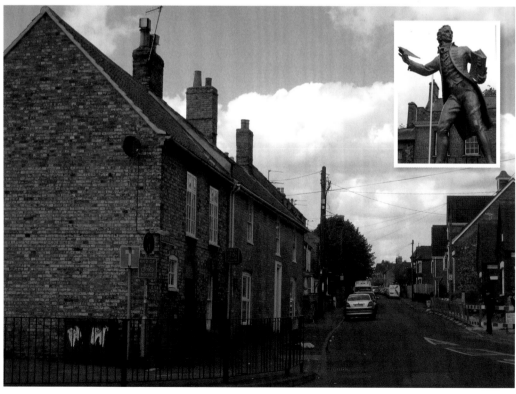

Allan Minns, Britain's First Black Mayor

Thetford has a unique claim to fame and one that deserves to be better known: it was the first town in Britain to erect a black mayor! Two brothers, Pembroke and Allan Minns, who were born in the Bahamas, worked for many years in the town as doctors: Allan was mayor for two years. Their sister Ophelia also lived in the town and Allan's son, also called Allan, was a medical hero at Gallipoli in the First World War. Pembroke is shown in the historic picture on page 56, second from the left on the podium.

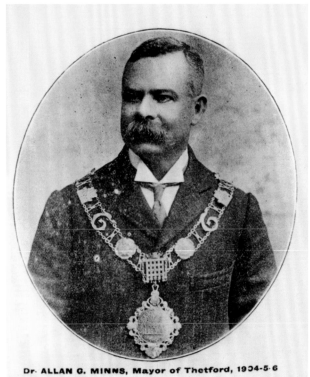

Dr. ALLAN G. MINNS, Mayor of Thetford, 1904-5·6

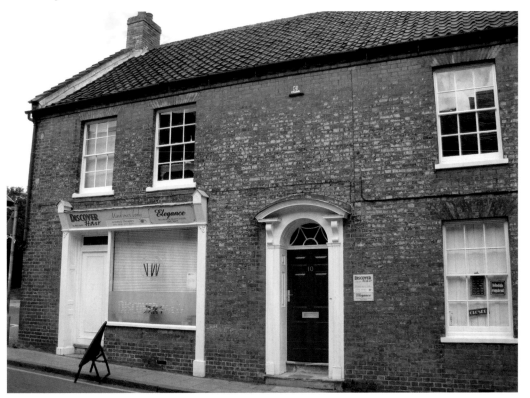

63

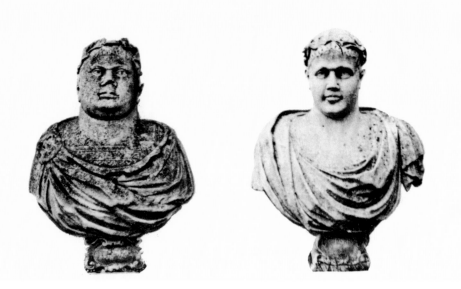

Allan Minns and Thetford's Theatre

Thetford was one of several East Anglian towns where the theatre was operated by the Fisher family. The building still exists: only the steep pitch of the roof and the ticket window adjacent to the door show that it was not always a private house. It was once adorned with busts of Roman emperors: Allan Minns was able to rescue two of them which can now be seen in the Ancient House Museum, opposite.

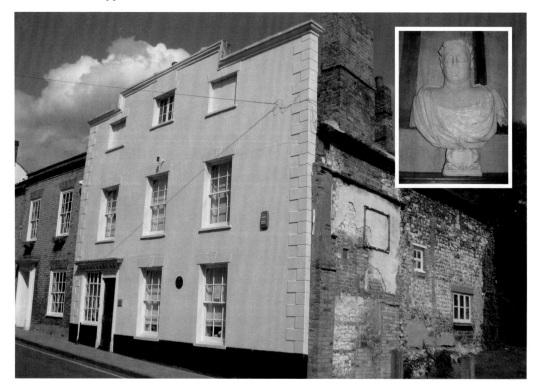

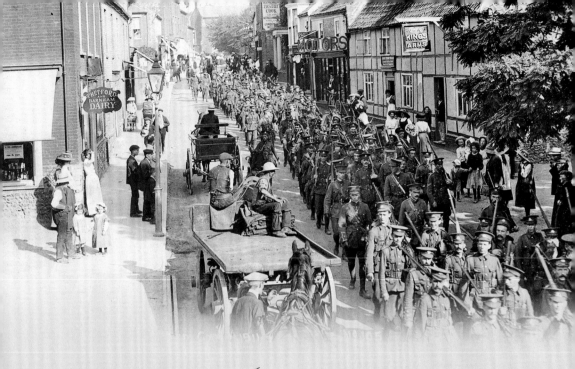

CHAPTER 6

Thetford in Two World Wars

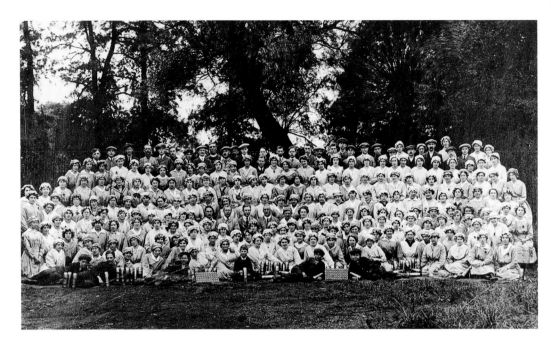

Munition Workers at Burrell's

When the First World War broke out in 1914, it was natural for great engineering firms like Burrell's to turn to weapons of war and to munitions. The historic photograph shows the munition workers at Burrell's in 1917. The war created new opportunities for women to work in skilled engineering: this could create problems after the war when the men released from the forces wanted to return to their old jobs.

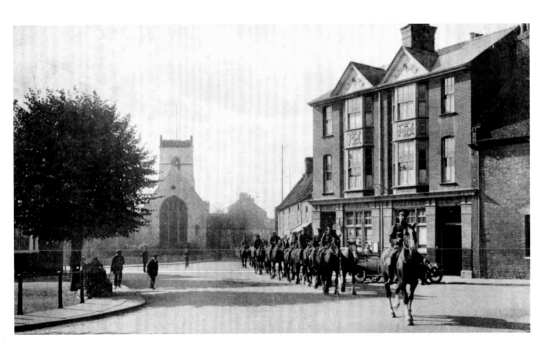

Troops in the Market Square

Breckland was an open area where troops could train, and one of the major innovations of war, the tank was developed in the region: however, the horse still had a major part to play in the war. These men are marching past the site where the war memorial was later erected: according to the *Norfolk Roll of Honour*, exactly one hundred Thetford men lost their lives in the First World War.

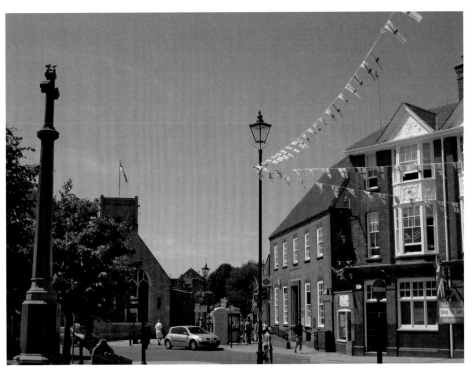

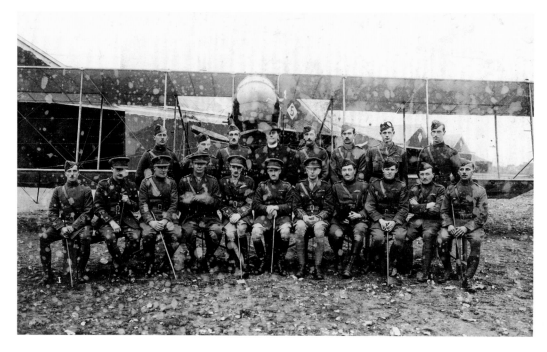

The Aerodrome at Snare Hill

Airships and aeroplanes were first employed at Snare Hill during army exercises in 1912. In 1914 it was selected as an aerodrome site and at one stage was intended to be the principal base for air operations in Norfolk, but was soon eclipsed by the aerodrome at Mousehold Heath, Norwich. Almost nothing remains of Snare Hill's place in aviation history: much of the land around Thetford is now used for pig farming.

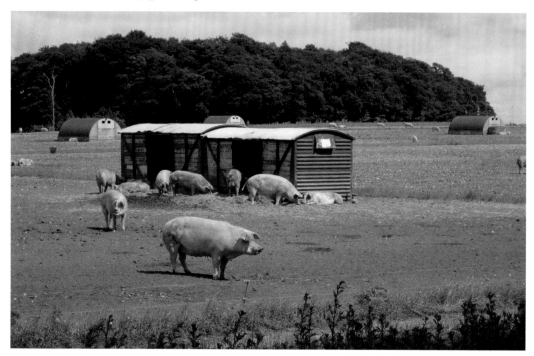

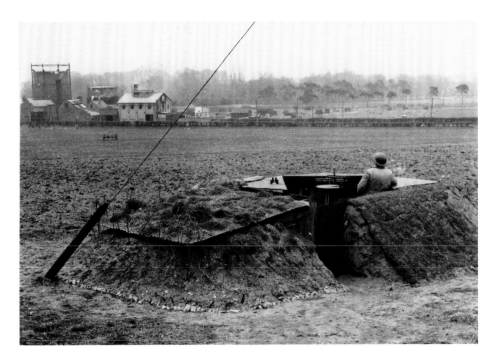

Defending the Realm

The historic photograph shows a Second World War Observation Corps Post in the fields south of Thetford: the gasworks can be seen in the distance. The popular BBC TV comedy *Dad's Army* was filmed in Thetford: Captain Mainwaring portrayed in the new statue in the town is a fictional character but he serves to remind us of the sacrifices made by Thetford men and women in the forces and on the home front in the war.

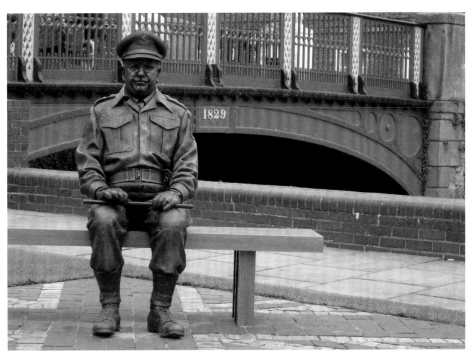

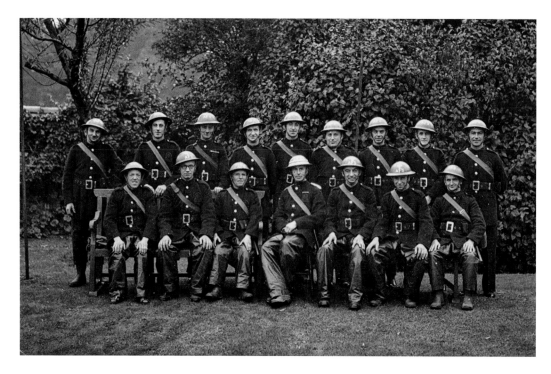

The Auxiliary Fire Service

All towns suffer fires: there were major fires in Thetford in 1667 and 1697. The threat of air raids in the last war led to the establishment of the Auxiliary Fire Service. Most of the men here were workers in the Patent Pulp factory, including Mr Sear in the centre of the front row who was Works Manager. Other people in the photograph include Ben Culey, sixth from the left in the back row, who ran the Palace Cinema.

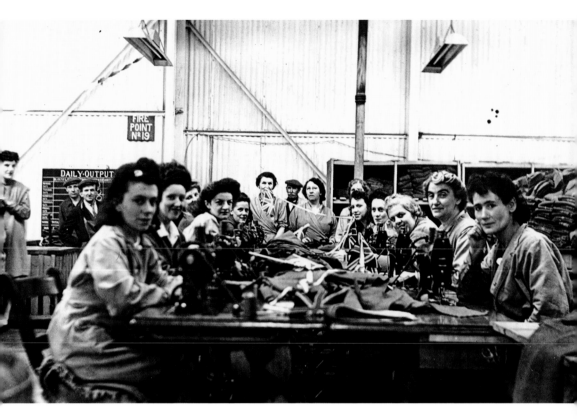

Working for Victory

The women of Thetford played their part in the Second World War too. The lives of Thetford people changed dramatically during the war, with blackout, food rationing, and with a large number of child evacuees from London. Some wartime structures remain such as pillboxes behind the railway station and on the Haling Path and spigot-mortar points at White Hart Street and near the Nuns' Bridges.

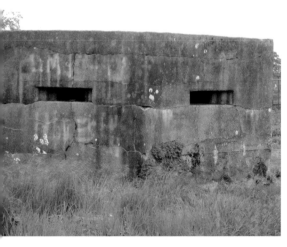

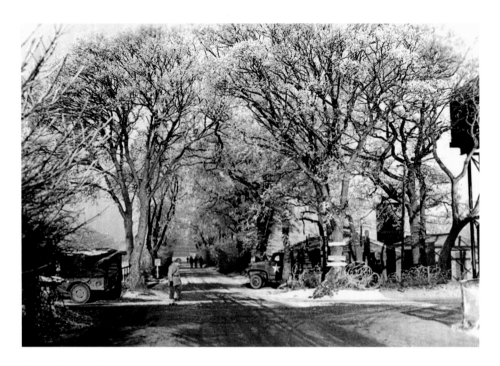

The Welcome Stranger

The war saw pilots of all nations serving in East Anglia, united in their struggle against tyranny. The first men at Wretham were from Czechoslovakia, which had fallen to Germany: they formed the 311 Squadron of the Royal Air Force. The airfield was handed over to the United States Army Air Force in the autumn of 1943. Part of the base, with its still-prominent water tower, continues in military use.

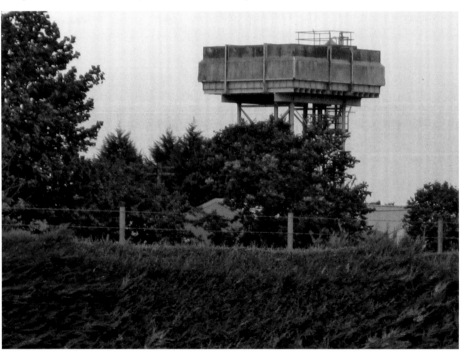

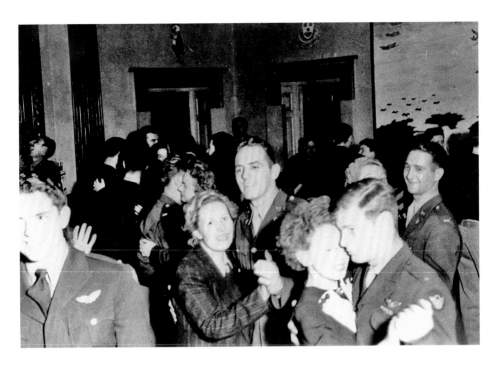

Wretham Air Base

The Americans were fighter pilots of the 359th Fighter Group, and were used to protect heavy bombers in air raids over Germany: 106 of their aircraft were lost in action. After the war ended, the airbase was used as a resettlement camp for military personnel from Poland, unable to return to their homeland. Most of the airfield it is now a nature reserve, with a few remains of runways and military buildings.

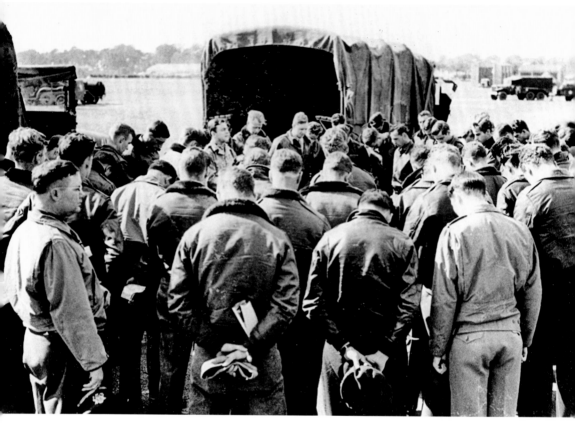

We Shall Remember Them

In the historic photograph, American airmen listen to a service at Wretham by their padre. Almost 7,000 American servicemen were killed in action serving from air bases in East Anglia. People from many other countries across the world also served in the Thetford area during the war, and many lives were lost, as the graves in Thetford Cemetery and the plaque on the Guildhall show.

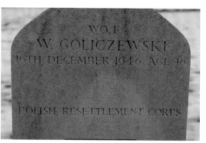

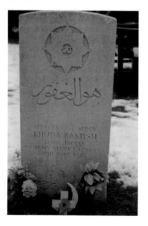

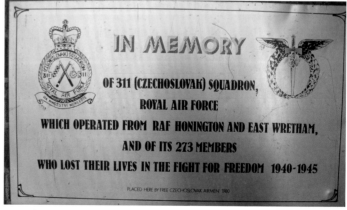

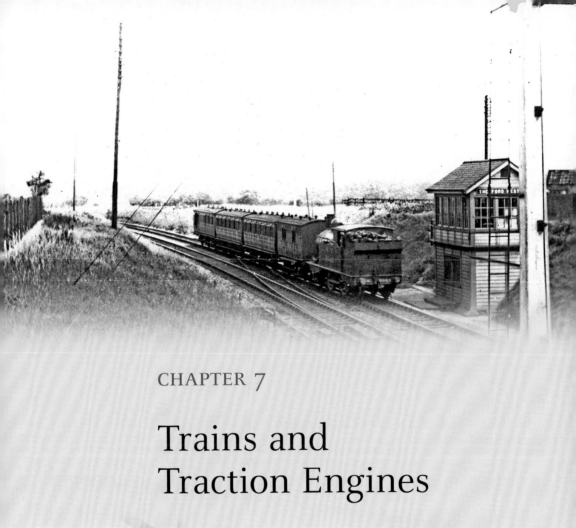

CHAPTER 7

Trains and
Traction Engines

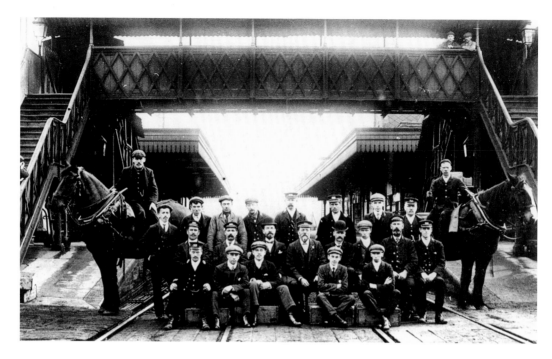

Workers at Thetford Station

Thetford was doubly fortunate in the railway age. Originally it was to be served by a branch from the main line between Norwich and Brandon, which would probably have been closed by now. When it *was* decided to bring the main line into the town, the first choice of site was the abbey ruins: luckily this proposal was never carried out! The line opened in 1845: the original station building still survives.

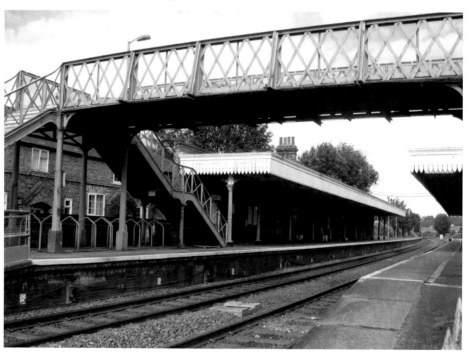

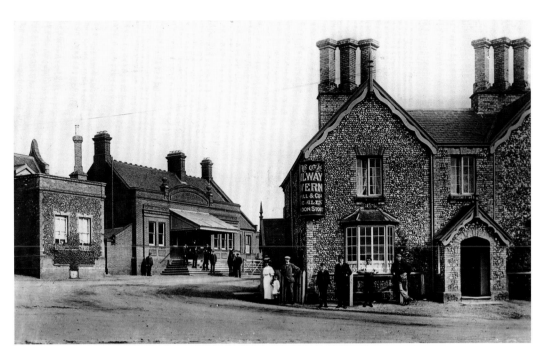

The Station and the Tavern

The Station Tavern has served passengers for well over a century. When the station itself needed enlarging towards the end of the century, the old one was retained and the new station building, this time of red brick rather than flint, was put up alongside it: it opened in 1889. The adjacent buildings make a nice contrast in styles of railway architecture.

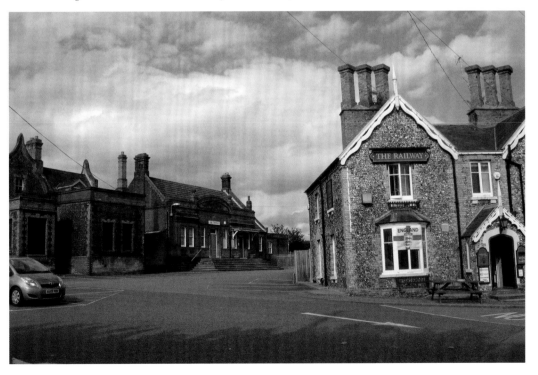

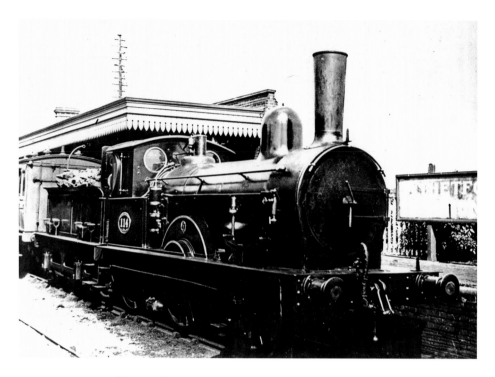

Steam Power at Bridge Station

Thetford Bridge station opened in 1867 for trains to Bury St Edmunds: a long way from the centre of town, it was named after Melford Bridge to which it was adjacent. The line was busiest during the two World Wars: there was a large military camp at Barnham from 1916, and an ICI Factory and bomb dump there in the Second World War. Melford Bridge has had a much longer life than the station: it is dated 1697.

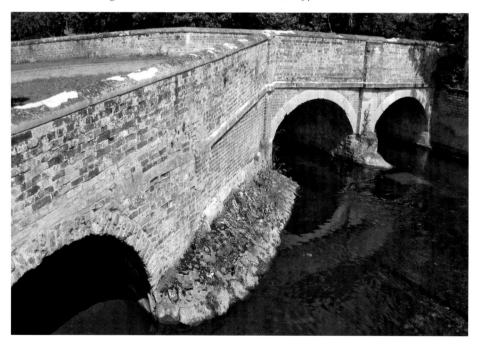

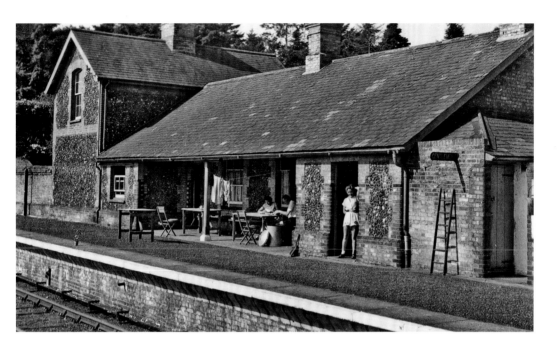

Thetford Bridge Youth Hostel

The station closed to passengers in 1953 and freight services ended in 1960. The track was lifted in 1963 and the station briefly became a youth hostel, as shown in the historic photograph. The building later became a Norfolk County Council road depot, and now lies under a modern roundabout and road: only one shed behind the roundabout remains as a reminder of the lost age of the railway.

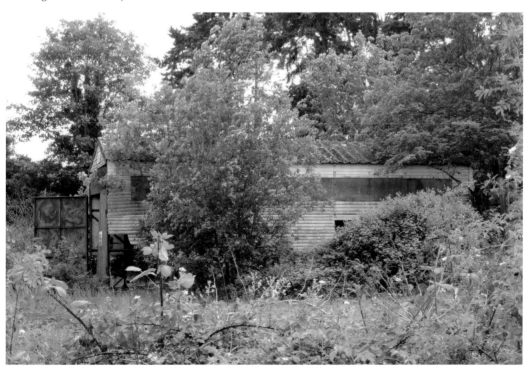

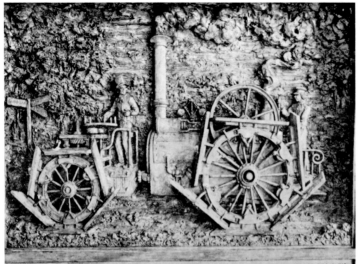

THIS MEMORIAL COMMEMORATES THE FIRM OF CHARLES BURRELL & SONS LIMITED WHO CARRIED ON BUSINESS IN THESE PREMISES FROM 1770 TO 1930 THEY PRODUCED THE WORLDS FIRST HEAVY-DUTY STEAM ROAD HAULAGE ENGINE IN 1856 FOLLOWED BY A GREAT VARIETY OF TRACTION & OTHER ENGINES & AGRICULTURAL MACHINES ERECTED BY PUBLIC SUBSCRIPTION IN 1957, BEING THE HUNDRED AND FIRST ANNIVERSARY OF THE ABOVE ENGINE LEAVING THESE WORKS

The First Traction Engine
The Burrell family was involved in iron working from 1740, and Charles Burrell built his first portable steam engine in about 1848. The plaque in the upper photograph is still visible on the wall of the factory: it was one of several similar plaques made in Norwich by John Moray Smith. He was actually an Italian by birth: his design is another contribution to Thetford made by an incomer.

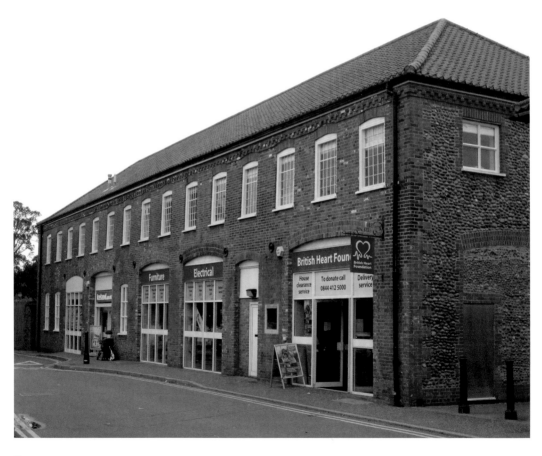

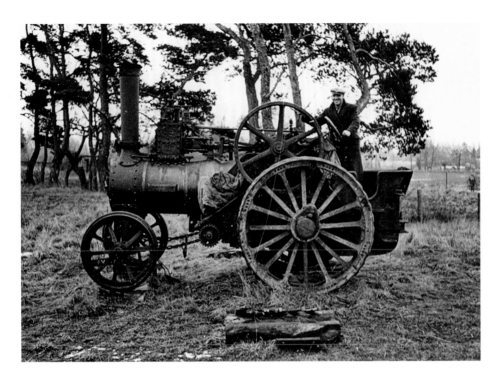

Burrell's of Minstergate

By 1879, the firm of Burrell's of Thetford was employing 200 men. A century ago the firm was described as 'traction engine, road locomotive and roller manufacturers and iron founders'. The Thetford works closed down in 1928. The largest building, formerly the paint shop, is now a fascinating museum.

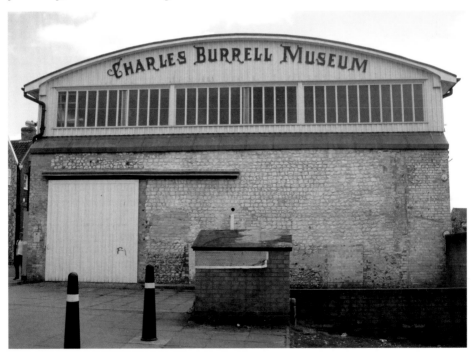

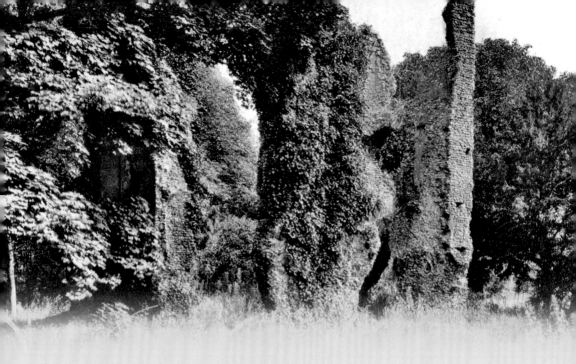

Breckland – Weeting, Brandon and Santon

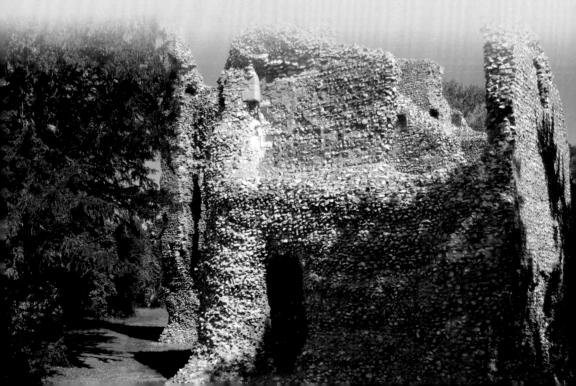

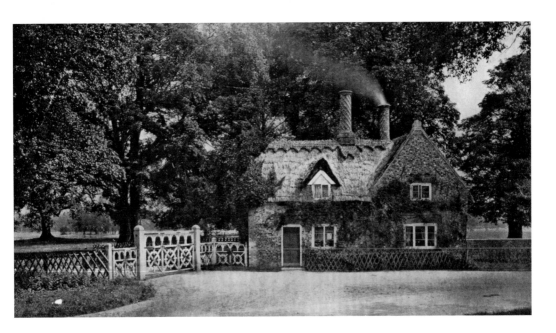

Weeting Lodge

The only castle in Breckland apart from Thetford itself is at Weeting, shown on the previous page, and it was more of a manor house surrounded by a moat: it was built by Sir Ralph de Plais in about 1180. Long deserted, the castle is now maintained by English Heritage. Weeting Hall was pulled down in 1952, but its nineteenth-century lodge survives with its thatched roof, now amongst modern houses.

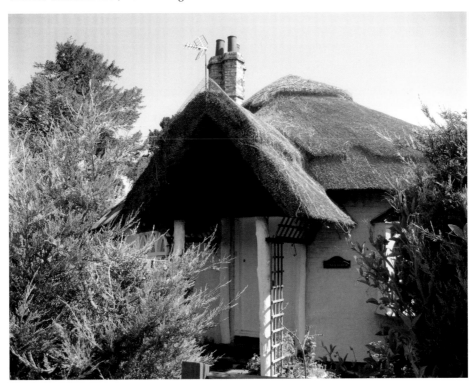

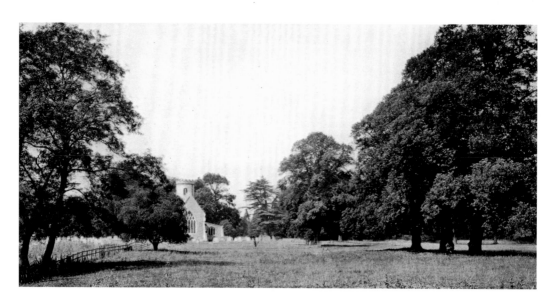

The Churches of Weeting

The sandy soils of Breckland supported quite a large population in the Middle Ages, as shown by the number of villages with two churches, including Wretham, Santon (where one is in Norfolk, the other in Suffolk!), and here at Weeting. This church is the only one in the village in use today, the other now just a ruin in a nearby field. The modern photograph shows houses of the Weeting Hall estate beyond the church.

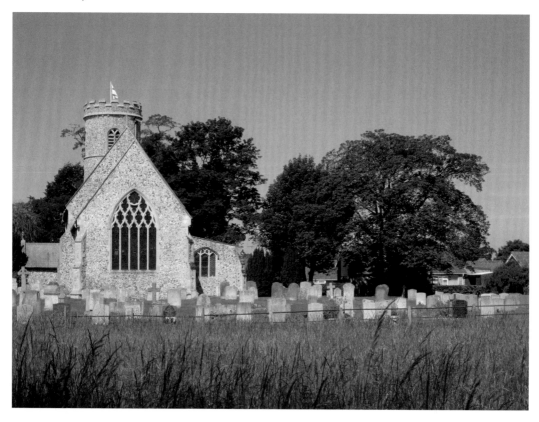

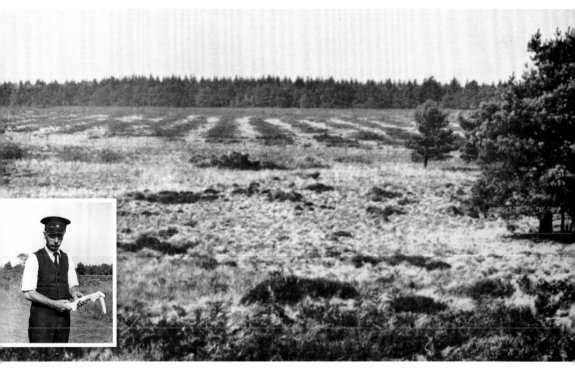

Grimes' Graves

This is the oldest industrial landscape in Britain, dating from two thousand years before the birth of Christ. There are almost four hundred pits, some up to 40 feet deep. The Iron Age miners were digging for flints: their only tools were picks made from the antlers of deer. The inset shows Mr Mitchell, keeper of the graves in the 1930s and 1940s, with an antler pick.

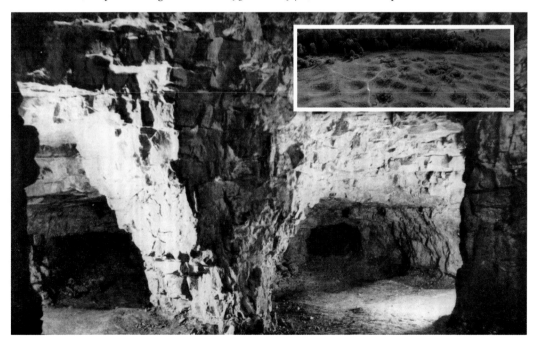

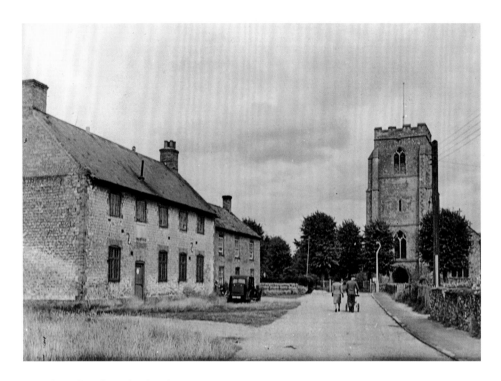

Brandon Church and School

Brandon church and former school are half a mile from the centre of the old town, but Brandon, like Thetford, has grown massively in the later twentieth century, with many newcomers arriving from London from the late 1960s onwards. The school is built of blocks of chalk and was opened in 1843 as the Victoria National School: it has now been converted into private houses.

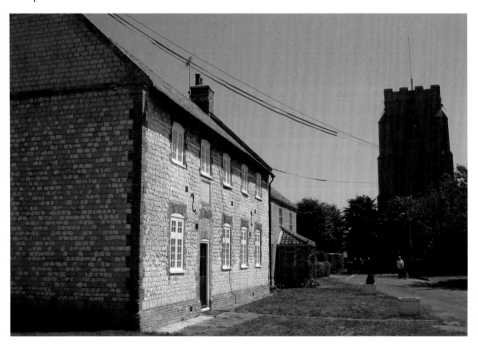

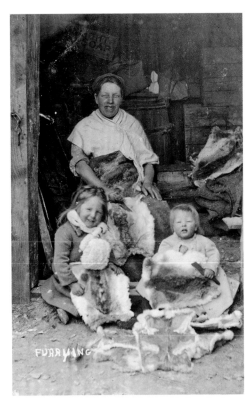

Rabbit, Rabbit, Rabbit

Breckland is rabbit country. They were valued both for their meat and for their skin – and local flints made ideal implements for scraping the skins! Black skins were especially prized, and are mentioned in the Paston letters written in the fifteenth century. A century ago, nearly 500 people in the Brandon district were working with rabbit skins: today the memory of the industry is preserved in a painting at the railway station.

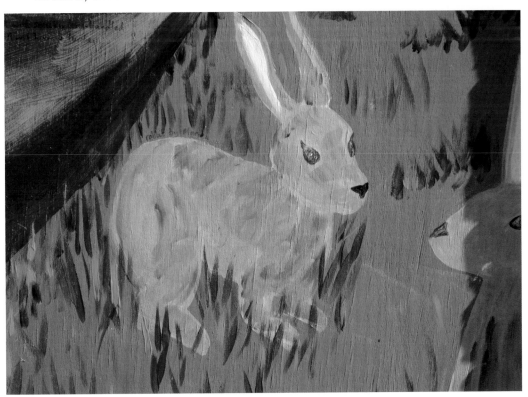

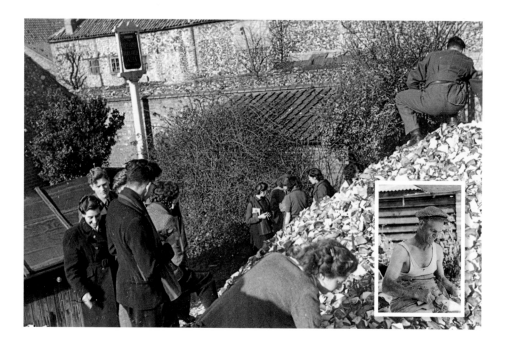

The Flint-knapping Industry

Brandon has long been the centre of the flint-knapping industry: the best flints are said to have been found on Lingheath Common, south east of the town. The industry involves splitting the stones and then cutting them into tiny squares: they are used for building, and also for making tools including the flintlocks in old rifles. The latter trade declined with the introduction of percussion caps, and flint-knapping is now recalled only in a pub name.

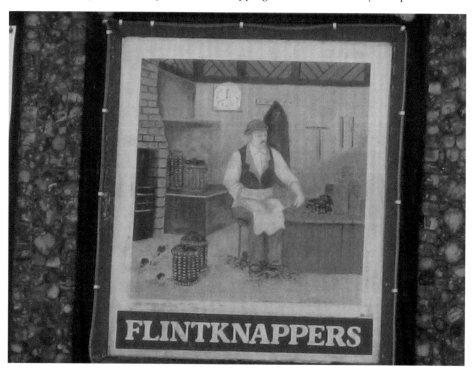

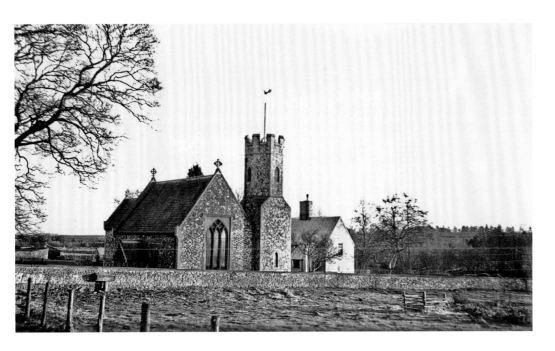

Santon Church

Santon church is across the Ouse in Norfolk: the delightful church has a farm beside it but there is no village. There was a medieval chapel here which was reused to create the church in 1628: The chancel, tower and north porch were added in 1858 using parts of West Tofts church, so recycling has flourished here for several centuries. Go in and look at the screen, possibly by the great Victorian architect A. W. N. Pugin.

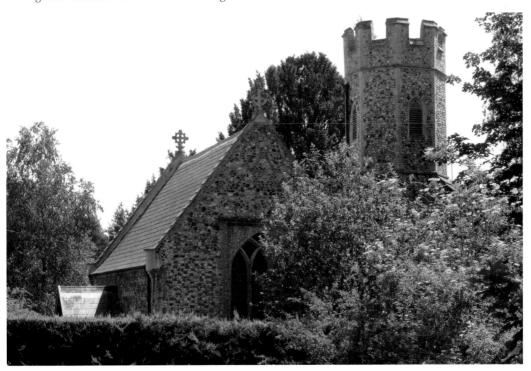

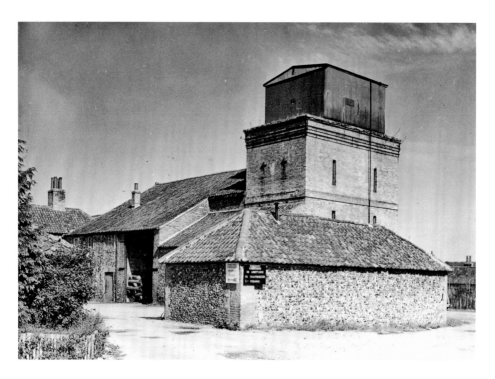

Santon Downham Timber Industry

Santon Downham, south of the river and in Suffolk, is at the heart of Thetford Forest, which was started in 1922 and covered 80 square miles by the 1970s. Almost all the inhabitants work in timber and a large Forestry Commission development was built in the village in 1967. The Forestry Commission employs about 300 men, and owns 330 houses within the forest, some of which are let out to holiday-makers.

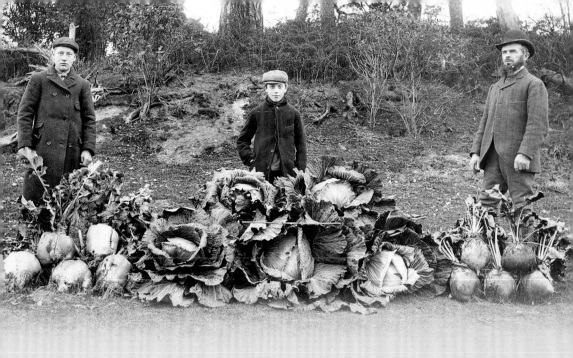

CHAPTER 9

Breckland –
Croxton and Wretham

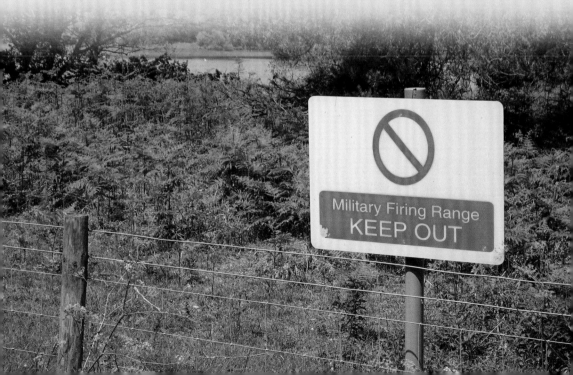

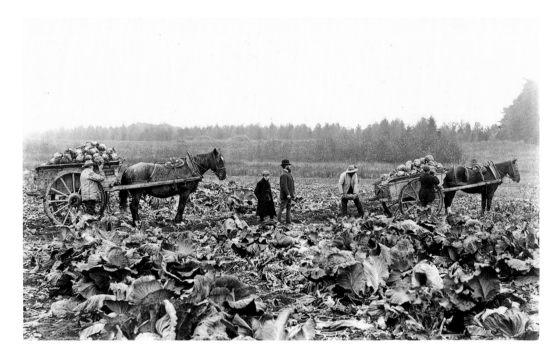

Fowlmere

The meres of Breckland are lakes that are sometimes full of water and sometimes totally dry: this depends on the water table in the underlying chalk bed and does not directly relate to the rainfall in the area. When they are dry, the soil is extremely fertile, Fowlmere producing enormous cabbages and root crops. Most unfortunately, this lovely mere is no longer accessible to the public as it is in the Battle Area, still reserved for troop training.

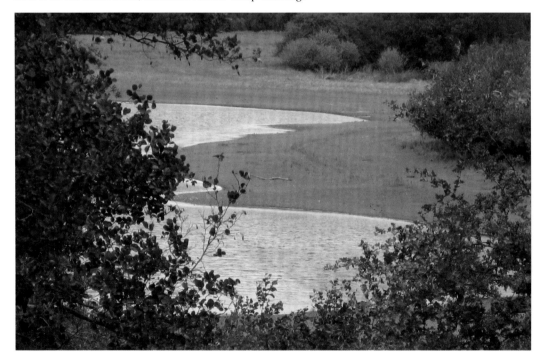

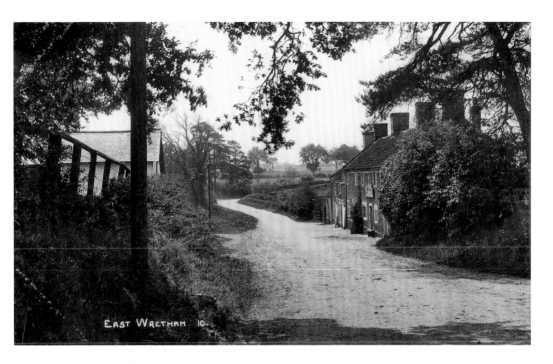

East Wretham Village

There were formerly two Wretham villages, each with its own church, but West Wretham has long disappeared, and its church (St Lawrence) was reduced to acting as the water tower of Wretham Hall! East Wretham is a scattered Breckland village, whose pub, the Dog and Partridge, welcomes thirsty walkers, many of whom are journeying on the nearby Peddars' Way, a former Roman road that is now a long-distance footpath.

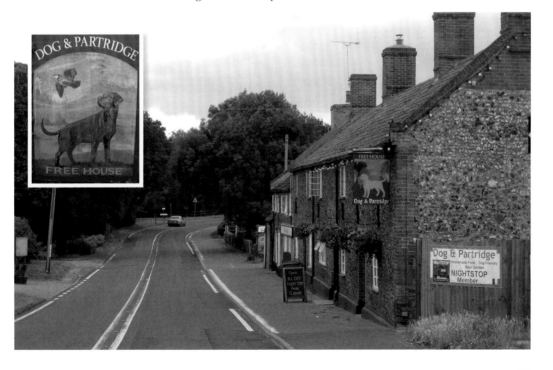

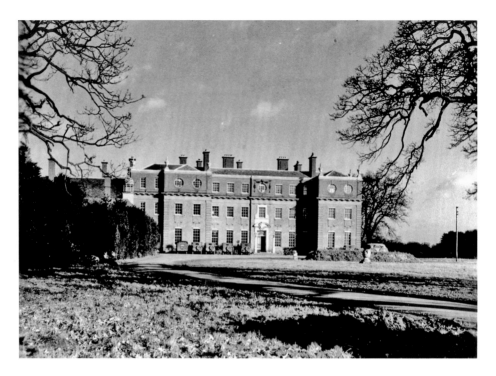

Wretham Hall

The Hall was rebuilt in 1912 after a fire: the owner was W. A. Noble and he employed the architect Sir Reginald Blomfield for the work. The historic photograph shows it in occupation by the United States Army Air Office and was taken by one of the Americans on the base. As the Hall has since been demolished, this is probably one of the last photographs to be taken of it. Deer and rabbits are now common sights on the estate.

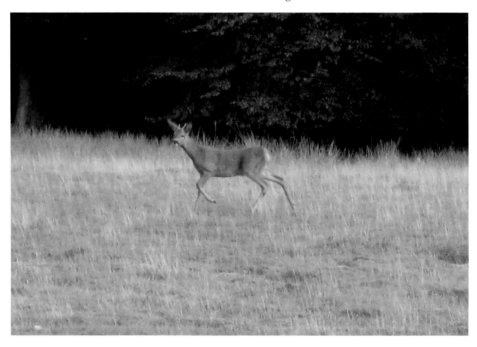

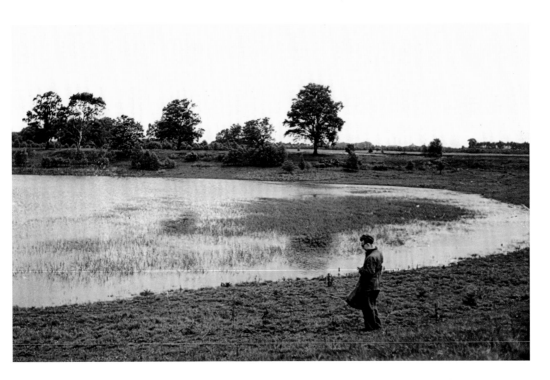

Ringmere and Langmere

Ringmere (above) and Langmere (below) are close together near Wretham Heath. This is the probable site of the great battle of Ringmer fought between native Saxons and invading Vikings in 1009. There is now a monument beside Langmere to Dr Sydney Long the founder of the Norfolk Naturalists' Trust: the first of its kind in the country, it looks after many of the most beautiful spots in the county. It is now known as the Norfolk Wildlife Trust.

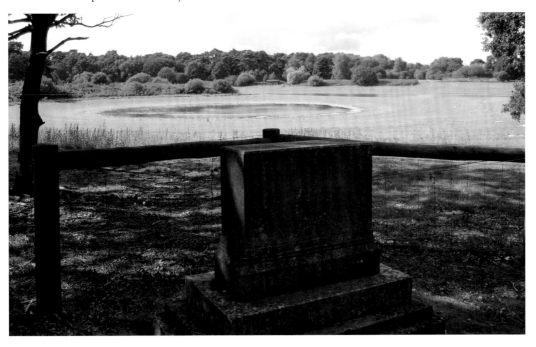

References and Acknowledgements

Many of the historic photographs are from collections at the Norfolk Record Office: I am most grateful to the Office, County Archivist Dr John Alban, for permission to use these images, which are listed below. The four images with the prefix MC 376 are from the collection of United States Army Air Force, held on deposit at the Record Office: I am especially grateful to the American Memorial Library in Norwich for permission to use these images.

The historic photographs on pages 47, 53, 57, 66, 69, 71, 76 and 78 are from the collections of the Ancient House Museum, Thetford: I am grateful for permission to use these. The modern photograph on page 57 is also in the Museum: it was taken by Studio Five, photographers, of Thetford who have most generously allowed me to use it in this book.

The historic images on pages 17, 18, 22-4, 27, 30, 31, 33, 34, 37, 44, 45, 48, 49, 56, 65, 75, 77 and 79 are from the vast collection of Thetford material owned by Mr Harold Preston, whose assistance I am very happy to acknowledge.

Norfolk Record Office references:

4, MC 365/132

6, ACC 2010/4

9, MC 365/133

12, MC 365/141

14, SO/WI/132

15, MC 365/155

19, ACC 2010/4

20, MC 365/176

21, MC 365/165

25, MC 365/147

28, ACC 2010/4

29, MS 11952

32, MC 365/159

35, MC 365/174

36, MC 365/137

38, MC 372/13

39, MC 365/134

40, MC 365/164

41, ACC 2010/4

42, MC 365/136

43, MC 365/168

46, MC 365/174

49 (lower photograph), MC 365/150

50, MC 365/151

51, MC 365/148

52, MC 365/160

54, 55, ACC 2010/4

58, ACC 2010/4

59, MC 365/174

60, MC 365/146

61, MC 365/161

62, MC 365/167

63, BOL 6/36

67, MC 365/174

68, MC 2600/2

70, ACC 2010/60

72-4, MC 376/287

81, ACC 2010/4

82, MC 365/189

83, MC 365/188

84, MC 365/189a

85, (inset) ACC 2010/4

86, ACC 2010/4

87, MC 365/20a

88, ACC 2010/4

89, MC 365/126

90, ACC 2010/4

91, MC 365/225

92, MC 365/226

93, MC 365/195

94, MC 376/287

95, ACC 2010/4